TALES
of
BRISTOL MOTOR SPEEDWAY

TALES of BRISTOL MOTOR SPEEDWAY

David McGee

Charleston · London
THE History PRESS

Published by The History Press
Charleston, SC 29403
www.historypress.net

Copyright © 2011 by David McGee
All rights reserved

Front cover image: Bristol Motor Speedway during the 2010 night race. *David Crigger*/Bristol Herald Courier.

First published 2011

Manufactured in the United States

ISBN 978.1.60949.145.1

Library of Congress Cataloging-in-Publication Data

McGee, David M.
Tales of Bristol Motor Speedway / David McGee.
p. cm.
Includes bibliographical references and index.
ISBN 978-1-60949-145-1
1. Bristol Motor Speedway (Bristol, Tenn.)--History. 2. Automobile racing--Tennessee--Bristol--History. 3. Racetracks (Automobile racing)--Tennessee--Bristol--History. I. Title.
GV1033.5.B757M35 2011
796.7206'80976896--dc22

2011011141

Notice: The information in this book is true and complete to the best of our knowledge. It is offered without guarantee on the part of the author or The History Press. The author and The History Press disclaim all liability in connection with the use of this book.

All rights reserved. No part of this book may be reproduced or transmitted in any form whatsoever without prior written permission from the publisher except in the case of brief quotations embodied in critical articles and reviews.

Dedicated to the memory of Jeff Byrd. Hopefully this project will exceed even your expectations.

CONTENTS

Acknowledgements 9
Introduction 11

1. Before the Roar 13
2. Good Neighbors 20
3. Start Your Engines 24
4. Perfect Attendance 32
5. Nobody Came 36
6. "World's Fastest Half-Mile" 39
7. Forgotten 500s 44
8. Caution Free 49
9. Flag to Flag 54
10. A Helping Hand 57
11. Under the Lights 60
12. "Anybody But Waltrip" 65
13. Trophy Dash 70
14. Racing through Bankruptcy 72
15. One Tough Customer 75
16. Prime Time 78
17. "Hardest Hit Ever" 81
18. Growing Together 84

Contents

19. Cementing Bristol's Future	88
20. A Champion Lost	92
21. The Water Bottle	98
22. Rattle His Cage	101
23. Quite a Track	105
24. The Road to Success	108
25. Bump and Run	111
26. Domination	115
27. Stunts to Students	118
Appendix: Race Results	121
Bibliography	139
Index	141
About the Author	144

ACKNOWLEDGEMENTS

Tales of Bristol Motor Speedway was a labor of love nurtured by the enthusiastic support and encouragement of many people. I am truly humbled by your trust and belief in this project.

Thank you, first, to the entire staff of The History Press, especially acquisitions editor Will McKay and project editor Amber Allen, for your guidance, expertise and enthusiasm.

To fellow author, journalist and friend Joe Tennis, thank you cannot begin to cover all your insightful advice and timely words of encouragement.

Special thanks to the entire staff and management of Bristol Motor Speedway, especially the late Jeff Byrd, Jerry Caldwell, Kevin Triplett, Wayne Estes, Lori Worley, Wes Ramey, David Rowe, Logan McCabe, Graig Hoffman, Ben Trout and Scott Hatcher, who responded joyfully to my pleas for help and answers to seemingly inane questions. Thanks also to Josh King for your regular words of encouragement and chauffer service.

Thank you to the management of the *Bristol Herald Courier* for allowing me time off for my "other job" and access to priceless archives and photographs. And let me also offer a word of praise for colleagues past and present whose timeless reporting helped fill innumerable gaps.

Thank you all around to track cofounder Carl Moore; his son, Randy Moore; my friends Shirley, Mark and Andy Carrier; Steve Smith and Lisa Johnson of Food City; Eddie Allison; Denny Darnell; Charles Earhart; A.D. Jones; Larry Baker; Randy "Crusher" Lewis; and Sidney Patton.

If a photograph is worth a thousand words, then thank you is totally insufficient to cover the contributions of John Beach, David Crigger, Chris

Acknowledgements

Haverly, Bill McKee, Earl Neikirk, Andre Teague and the late Mike O'Dell. I only hope my words can support your images.

Much needed assistance and encouragement also came from Automobile Racing Club of America historian Brian Norton and Jeff Gilder of racersreunion.com. Both your efforts to preserve our sport's history are critically important. You guys rock.

For all of the racers whose wonderful first-person accounts helped breathe new life into decades-old stories, you are truly my heroes.

Speaking of heroes, thank you Debbie Helton for your love, encouragement and support when I needed it most.

To the research staff of the Bristol Public Library and Lorie Bradley, thank you for your efforts to make this project exceed expectations.

Finally, much gratitude to my family, especially my mom, Phyllis McGee, for encouraging me to pursue my dreams, starting with a freelance job writing about stock car racing at age seventeen. It has been quite a ride.

INTRODUCTION

Tales of Bristol Motor Speedway is a love story. A real-life narrative of an unwavering, abiding commitment between people of all ages, from all walks of life and a seemingly inanimate object. Hailing from small towns and large cities, from coast to coast and faraway shores, people the world over love Bristol Motor Speedway, proving their affection with semiannual treks to the mountains of Appalachia and casting their votes with hard-earned dollars.

Like Elvis, Bristol is recognized by its first name. Utter that name anywhere racing is spoken, and listen to the outpouring of last-lap bump-and-run moves, fender-banging action and tempers boiled over. Others will describe scenes that have nothing to do with racing, like doing the wave or singing along during that world-record karaoke rendition of "Friends in Low Places." After all, the experience is half the fun at east Tennessee's version of Mardi Gras. Can you say Jelloville?

Race track owner Bruton Smith calls Bristol a "phenomenon" and "NASCAR's crown jewel." Oh, how right he is. Under the guidance of Smith and the late track president Jeff Byrd, Bristol Motor Speedway grew to become one of the world's foremost sports destinations. Countless publications and fan polls consistently rank Bristol as racing's favorite track and the August night race as the one event everyone should witness first hand. If that isn't love, what is?

Only true affection would prompt someone to leave comfortable lives, drive hundreds or thousands of miles and wait—sometimes for weeks—to claim their favorite campsite in the speedway's shadow.

Introduction

Devotion to Bristol outlasts marriages and even life itself; witness the inclusion of season tickets in divorce and estate settlements.

Like the sport it hosts, Bristol's speedway continues to evolve. Primitive concrete grandstands gave way to high-rise aluminum, top-row box seats are now air-conditioned luxury suites and the racing surface—cussed and condemned for decades—has transitioned from modestly banked asphalt to wider, faster concrete.

The track's name has also changed a few times, and this book refers to its name at the time specific events occurred.

Upon reflection, Bristol's race track may actually be a living being with feelings and emotions. Given the number of male suitors, one could assume the speedway is female. If so, she certainly is fickle with moods, ranging from cantankerous and unyielding to caring and compassionate. Bristol willingly welcomes drivers who court her favor with open arms, while others may go away heartbroken and unsatisfied.

While you can watch Bristol on TV, the small screen pales to the first-hand experience.

Nothing compares to the electricity in the moments before cars roll off pit road, from the invocation; the "Star-Spangled Banner," with your hand over your heart when you actually feel it beating, to the flyover when we pause to think of our freedoms; and the words we've all been waiting to hear: "drivers, start your engines!"

Everyone who experiences Bristol has a story to tell. This book samples some of the most significant from the track's first fifty years. It could easily be entitled *Moments in Speedway History* since most chapters begin at a specific juncture. Some are seemingly mundane but lead to the monumental, while others represent the zenith, belying a back story of weeks, months or years of preparation. These are tales of overcoming great odds, succeeding in the face of failure and coping with unspeakable tragedy. These are moments that changed the course of Bristol's colorful history or added immeasurably to it.

Whether you know nothing of Bristol's renown or have reveled in it for decades, come along as we tell the *Tales of Bristol Motor Speedway*.

Chapter 1

BEFORE THE ROAR

Waiting anxiously outside the Daytona Beach, Florida office of Bill France Sr., the founder and president of the National Association for Stock Car Automobile Racing, Larry Carrier and Carl Moore didn't know they were about to embark on the greatest adventure of their lives.

They'd come to America's birthplace of speed in the fall of 1960 to propose a crazy scheme with seemingly no chance of success: to build a race track in the hills of east Tennessee. Not just any track but a world class facility worthy of attracting France's burgeoning Grand National circuit.

Carrier was thirty-seven, a successful homebuilder, bowling alley proprietor and former Golden Gloves boxer who grew up in Bristol, Tennessee. He enjoyed sports and the challenge of making money. Seven years his junior, Moore was involved in banks and a savings and loan company and sat on the board of a pharmaceutical firm. He'd also had some business dealings with Carrier but nothing on this scale. They probably never stopped to think France might quash their dream.

This unlikely journey actually began a few weeks earlier, on October 15, 1960, when Carrier went to watch a race at the new Charlotte Motor Speedway in North Carolina. While Carrier didn't consider himself a race fan, confining his speedy driving to the highways, he'd heard about NASCAR and wanted to see what all the fuss was about.

That same morning, Moore headed in the opposite direction, to Knoxville, Tennessee, to watch his beloved University of Alabama play football against archrivals the University of Tennessee. While the game's outcome wasn't to

his liking, Moore's mood improved later that night when Carrier telephoned his hotel room.

"You've got to come over to Charlotte to see this," an excited Carrier nearly yelled into the phone. "There's thousands of people here, paying $10 to $15 a head to watch people race stock cars. I think it might be a good venture."

Moore wasn't initially excited, having already seen one NASCAR race. When he ran the Pirate's Den bar in Florida in the 1950s, he'd actually sponsored a car on the old Daytona Beach and Road Course. The car didn't win, but when it broke down in the middle of the track, officials let it sit there all day and fans couldn't miss seeing the name of Moore's little waterfront bar.

But Carrier persisted until Moore finally relented.

"I flew over to Charlotte the next day, and we sat in the stands and saw that race," Moore said. "It was a long race with plenty of crashes, and more than once I asked Larry if we could go." But Carrier kept telling him, no. Why no? Because the wheels inside Carrier's head were turning faster than those on National 400 winner Speedy Thompson's Ford. What, Carrier thought, if they built something like this in northeast Tennessee?

Once back home, the two men met for dinner at Bennie's Drive-In Restaurant, a cozy little hamburger-and-hot-dog place popular with the local high school set. They talked about the crowds, the excitement, the danger and what looked like a chance to make a lot of money. Convinced it was a great opportunity, the audacious duo decided to travel to Florida and pitch their plan to NASCAR's founder.

"We got in to see Bill France," Moore recalled. "We talked, and he sent us to talk to Pat Purcell, who was their executive manager. He was a carny—an old carnival promoter."

In fact, Purcell was France's right hand. A native North Dakotan, Purcell joined up with France's fledgling organization in 1952 and helped organize moonshine runners, outlaws and other daredevils into a respectable racing series for full-bodied stock cars. Purcell took a liking to Carrier and Moore, so he and the naïve yet ambitious duo went out on the town.

"I didn't smoke," Moore said. "But we went to dinner and smoked an old, green cigar and had drinks. Well, Pat said he believed we could build a track."

Problem was, they had almost no money, knew nearly nothing about racing and even less about building or running a race track. They didn't even own land on which to build their dream. Besides guts, Carrier and Moore had one other thing on their side: their timing was perfect. Stock car racing, in 1960, was starting to boom. Charlotte had its new track, while another

paved one-and-a-half-mile track opened that year in Atlanta. Combined with Bill France's massive new two-and-a-half-mile paved superspeedway in Daytona Beach, Florida, the sport was outgrowing the dusty, rutted dirt tracks common in the 1950s.

When Carrier and Moore returned to NASCAR headquarters the next morning, they again met with Purcell, who had spoken with France, and he simply asked what dates they wanted. Just like that, a top NASCAR administrator offered two dates on the Grand National schedule—dates that would be worth hundreds of millions of dollars today. They looked at a calendar and selected July 30 and October 31, 1961. When they were done, Purcell shook hands with two guys who came to town with nothing more than a dream and left as race promoters.

Once the excitement of securing their race dates subsided, the reality was Carrier and Moore now had less than nine months to find and buy land and design, build and promote a race track. They first enlisted Larry's father, Robert Hugh Carrier, who was a commercial real estate agent. His search turned up rolling Tennessee farmland in Piney Flats, midway between Bristol and nearby Johnson City. While the land seemed ideal for the track they envisioned—something about a mile in length—there was a problem. A couple of local preachers learned about the race track plan and were trying to stop it.

"So we had a meeting to listen to what the community had to say," Moore said. "Most everybody there was for us, but there were two preachers who didn't like it. They thought racing would bring in all kinds of undesirable elements—drinking and gambling—so we decided if Piney Flats didn't want us, we'd go someplace else."

Undaunted, Carrier met with municipal leaders of Johnson City, a growing college town, about possibly building his race track on land near the Johnson City Airport. That meeting was set up at the urging of local race driver Paul Lewis.

"I don't think they took us seriously," Lewis lamented of city leaders. "Racing, at that time, had a bad reputation, and they really weren't interested. They kind of looked down their noses at us, but that site would have been perfect."

Carrier and Moore soon turned their attention to a one-hundred-acre dairy farm, located just off U.S. 11 East, only four miles south of Bristol, Tennessee. It had good highway access and visibility, parts of it were flat (no simple feat in the hilly region) and owner Winnie Carter wanted to sell. But how would they pay for it?

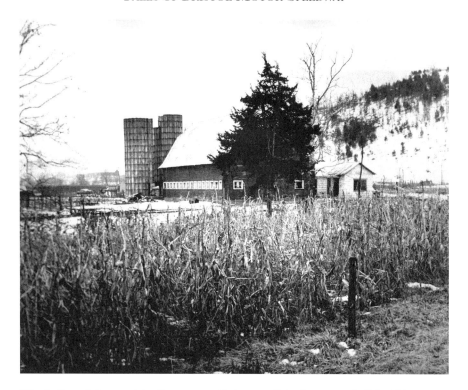

Winnie Carter's former dairy farm eventually became Bristol's race track. *Bristol Motor Speedway collection.*

"We figured it would take $600,000 to buy the land and build the track," Moore said. "But nobody would talk to us. We went to every bank around, and we couldn't even get a seat to sit down."

Growing desperate, Carrier again approached Bill France, who suggested they contact the Berlo Vending Company, a Philadelphia-based concessionaire of major league baseball parks, professional football stadiums and drive-in movie theaters. Carrier and Moore flew to New Jersey, presented their plans at dinner—again over cigars and drinks—and got the answer they were searching for—sort of.

"They agreed to loan us the money at something like double the interest rate, and we had to give him the concession rights for fifteen years," Moore said, holding up his hands as if someone pointed a gun in his direction. Nearly out of options and with that July race date drawing ever closer, they agreed to the terms.

With money in the bank and the farm's purchase complete, they began to design the track. Carrier and Moore always envisioned a course

between three quarters to one mile in length, more intimate than the giant tracks but larger than the half-mile short tracks predominating NASCAR's schedule at the time. Trouble was, their new property was nearly encircled by Beaver Creek, the highway ran along its northern border and two steep hills lay in the middle. Returning to Bennie's Drive-In Restaurant, Carrier and Moore were joined by newly recruited partner R.G. Pope, who owned a successful construction company. Together, this trio sketched the track's layout on napkins and realized they would have to settle for a half-mile oval.

"It was all we could build," Moore said. "It was all we had room for, with the creek and the highway. But it worked out pretty good because we could cut the concrete stands into those hills."

After visiting other prominent short tracks in Martinsville, Virginia, and Asheville, North Carolina, Carrier insisted Bristol should stand out. Not only would it have a paved surface, but its corners should be banked so drivers could race faster and make the show more exciting.

They gave those primitive sketches to architect Gene Rawls of the Johnson City firm Godwin and Rawls to create a formal design. Plans were first unveiled publicly during a press dinner in Bristol on January 17, 1961, two days before John F. Kennedy became president. At that time, Moore

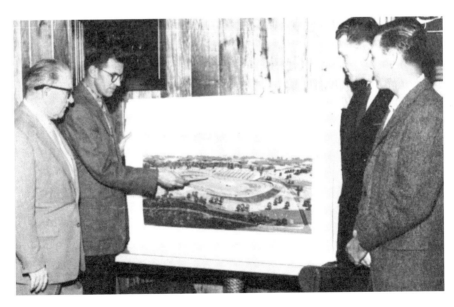

Larry Carrier *(second from left)* points out design features while Pat Purcell *(left)* of NASCAR, Carl Moore *(second from right)* and W.W. "Bud" Walling *(far right)* watch. *Author's collection.*

predicted the facility could also be used for "civic, religious and political events, horseshows, county fairs and other sporting activities."

Work began January 27, just 184 days before the first green flag was scheduled to fly.

In the ensuing months, workers moved tons of dirt to create twenty-two-degree-banked corners and relatively flat straightaways, while employees of Atlas Concrete poured the eighteen thousand grandstand seats that had been carved into the two facing hillsides.

As summer arrived, the final step showcased R.G. Pope's workers applying and rolling tons of asphalt to complete the racing surface. Steel cables were used to secure the machinery, so it didn't tip over in the turns.

By the time they opened the gates for that first race, NASCAR's newest track would sparkle like a diamond in the Tennessee sunshine, with its gleaming steel guardrails encircling wide black asphalt and an expansive grass infield.

In a message to fans in the souvenir program of the inaugural Volunteer 500, Carrier expressed obvious pride:

> *You are welcome to inspect this new racing plant—the finest half-mile racing plant in the entire United States—with a modern track, a first-class*

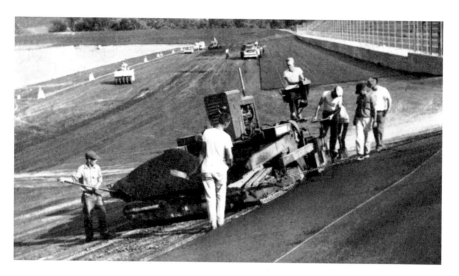

R.G. Pope's construction company performed much of the work to build the speedway in six months. *Author's collection.*

grandstand, a press box second to none in the business and other facilities that make the stockholders proud of their investment.

The opening of this million-dollar-plus speedway—the first major racing plant for the entire state of Tennessee and finest half-mile track in the nation—brings to the Bristol area something new and different.

When the stockholders of Bristol International Speedway Corporation decided on building this ultra-modern speedway, they decided to go first class in every respect—nothing but the finest for Bristol and the eastern section of Tennessee. Nothing was spared to make it the finest.

How this speedway suddenly became a "million dollar plus" facility still remains a mystery. Remember, the owners just borrowed $600,000. But the track's own souvenir program quite comically contradicts itself, describing Bristol as a "multi-million," "$1.25 million" and "$1.5 million"–dollar facility, while the radio network broadcast of the first race reported the speedway's value was $1.25 million.

Even a newspaper headline, when the track was first announced, touted Bristol as a "million dollar" speedway, but Moore is emphatic that he and Carrier didn't spend that much.

Decades later, as the track approached its golden anniversary, Moore still couldn't explain the discrepancy. "I don't know where those numbers came from—we spent $600,000," Moore said, and then chuckled and contemplated the suggestion that his late partner might have embellished the total.

Smiling, Moore said, "Larry was good at that."

Chapter 2

GOOD NEIGHBORS

July 30, 1961, began like most Sundays for Phillip Earhart, who milked his cows, changed clothes and took his family to the Blountville Presbyterian Church in nearby Blountville, Tennessee. But this wasn't any Sunday. It was the day they would run the first Volunteer 500 at the new Bristol International Speedway, right next to Earhart's dairy farm.

"We were at church, and Daddy came out between Sunday school and church and saw it was just a steady stream of traffic," Charles Earhart recalled. "So he decided he'd better come home to see what was going on. When he got here, they'd torn down all his fences, walking across the field."

Earhart owned about 125 acres next to and across the highway from the new speedway, so when parking lots on race track property filled, fans began parking in his fields or walking through them to reach the track.

Phillip Earhart and his nephew, Sidney Patton, spent most of the afternoon fixing those fences. "I told him not to," Patton recalled. "Because we'd just have to fix them back once it was over. And we did. They tore every one of them down again."

Charles, who was six at the time, said his father planned to make the crowd go around his property after the race ended but was soon overwhelmed. "While he would stop one, ten were going by," Charles Earhart said. "So they worked until after dark fixing the fences again."

Earhart and other wary neighbors didn't know what to expect, but Patton believes that first race brought what was "probably the biggest crowd that had ever been seen around here at that time."

Their first indication of what was to come occurred a few days before the race.

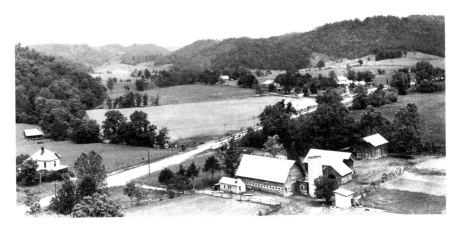

Then as now, the Earhart family farm was just across the highway and the creek from speedway property. *Courtesy of Charles Earhart.*

"A man came and offered my father $1,000 to rent the field and park cars," Earhart said. "But Daddy told him he'd never made his living on Sundays, and he wasn't about to start. After that first race, I guess he figured if you can't beat them, join them. The second race, we started parking cars, and it has developed into what it is today."

It is Earhart Campground, the first, among the largest and easily the most commercially developed such enterprise surrounding the speedway property on race weekends.

Once a large dairy farm, the Earhart family's acreage on both sides of U.S. Highway 11 East now yields mostly hay each summer. For most of the past five decades, however, campers and fans who parked there had to contend with what cattle leave behind.

"The fresh cow patties out there—the women would step in it and think it was gross," Earhart said. "But the men would think it was the funniest thing that ever happened."

One fan in particular may never forget—no matter how hard he tries—a late-night stroll across the Earhart property.

"It was the August race, and we had just scraped the barn," Earhart said. "You don't have very much manure in the summer because the cattle are out in the field all the time, so it wasn't much more than two feet deep. But a gentleman had left the race halfway through. He was looking for his car and walked out into the pile of manure. He'd lost his balance, fell and was on his back. He looked like a fish flopping."

The race track was carved out of land next to the Earhart family farm. *Courtesy of Charles Earhart.*

Earhart and another man picked up the unfortunate fellow, led him to the barn and used a water hose to try and wash away the mess.

"No telling how many miles they had to drive home, but that smell would never come out of the car—never," Earhart said.

The cattle are gone now, relocated to other family property, and the Earharts have expanded the campground's commercial display space so the makers of pickup trucks and cellular phones not allowed on speedway property can promote their wares. Much like successful crops, what began with a couple rows of trailers selling souvenirs has grown wildly.

"We have about as much to offer as the track," Earhart said. "Everything is numbers with these companies, how many people go through their exhibit. With our proximity, we have as many or more people who walk through our property than actually park here."

Entertaining fans has also meant hosting everything from corn hole tournaments to concerts by Dierks Bentley, Doyle Lawson & Quicksilver, Blue Highway, Travis Tritt and Rhonda Vincent.

Fans have become loyal customers, including an amazing group who, each summer, line their motor homes along a gravel road at the front of

Earhart's property to camp for days and weeks without benefit of hookups. Their arrival, usually about three weeks ahead of the August race, signals the unofficial beginning of summer race season in Bristol. Earhart isn't sure why they come so early, but he appreciates their loyalty and enthusiasm.

After working with every speedway owner—from Larry Carrier, Carl Moore and R.G. Pope to Lanny Hester and Gary Baker, Warner Hodgdon, Carrier again and Bruton Smith—Earhart believes all have benefited.

"I'm real proud of our relationship with the track," Earhart said. "They do a lot for us, and we do a lot for them. I don't know if I was lucky or had the foresight to make investments in earlier years, but I feel like some of what we did helped them in their growth."

Chapter 3
START YOUR ENGINES

Johnny Allen sat on the hood of Jack Smith's Pontiac clutching a trophy, surrounded by beauty queens and smiling for photographers as a sellout crowd looked on. After five hundred grueling laps around the all-new Bristol International Speedway, it was a most improbable ending to an extraordinary day.

While Jack Smith will forever be listed as the winner of Bristol's first NASCAR race, it was Allen who came on in relief on a steamy late July afternoon to muscle his friend's ill-handling behemoth to the checkered flag of the 1961 Volunteer 500.

The only people smiling more than Smith and Allen were the day's other winners: track owners Larry Carrier, Carl Moore and R.G. Pope. After all, they had managed to establish their new race track in just six months and then attract a sellout crowd of about twenty-four thousand to its first race.

NASCAR's arrival in east Tennessee proved a major social event for local folks, many who came straight from church sporting white shirts, ties and their best Sunday dresses. Tennessee governor Buford Ellington proclaimed it "Volunteer 500 Week" in the state, and prerace festivities included a performance by the local Tennessee High School marching band and Miss America Lynda Lee Mead. Bill France, the president and founder of NASCAR, showed up to welcome the crowd and to see for himself that those crazy Tennesseans had indeed made good on their promises.

The weekend began on a successful note, as a crowd of eleven thousand—reportedly one of the largest ever to attend a NASCAR qualifying

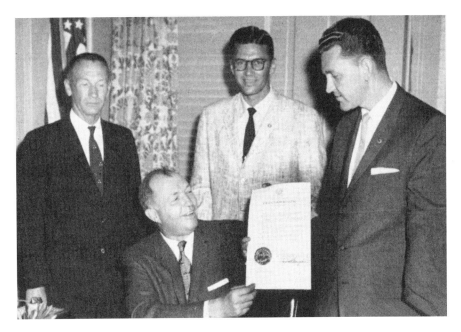

Tennessee governor Buford Ellington *(seated)* proclaims Volunteer 500 Week as Bristol owners *(from left)* R.G. Pope, Larry Carrier and Carl Moore watch. *Author's collection.*

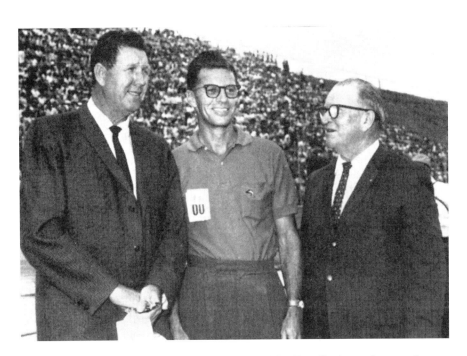

NASCAR founder Bill France *(left)*, Larry Carrier and Pat Purcell prior to the start of Bristol's 1961 Volunteer 500. *Author's collection.*

session—braved the threat of rain to watch Friday's practice and time trials. They saw Fred Lorenzen turn in the day's fastest time, wheeling his Holman-Moody Ford to a top speed of 79.225 miles per hour on the virgin asphalt. When qualifying was complete, Junior Johnson earned the other front-row spot. Former rookies of the year David Pearson and Richard Petty qualified fast enough to start on the second row, while veterans Buck Baker and 1960 champion Rex White qualified for row three.

Bristol's first race attracted forty-two cars; a superspeedway-size field compared to the twenty or twenty-five that typically showed up at most short tracks. Then again, Bristol wasn't like most short tracks.

Other stars of the era, including Fireball Roberts, Ned Jarrett, Joe Weatherly, Nelson Stacy, Jim Paschal, and Tiny Lund were all in the starting field. Alongside them were east Tennessee drivers Paul Lewis, Herman Beam and George Green of Johnson City; Bill Morton of Church Hill; and three members of nearby Bluff City, Tennessee's Utsman family: Dub, Layman and Sherman.

Besides the racing spectacle, thousands also came out Saturday night to watch the Miss Volunteer 500 beauty pageant and a country music concert by Brenda Lee.

On Sunday, eager race fans from twenty-six states and Canada began settling into their seats hours before the 1:00 p.m. start. Moore later admitted the promoters worried so much about attendance that they gave away many of the tickets—priced at six, seven and eight dollars—on Sunday morning. Those who arrived too late to sit on one of eighteen thousand concrete seats were still in luck, finding vantage points by climbing nearby hillsides or standing along the fences.

Because Bristol opened to a full house, NASCAR executive manager Pat Purcell had to pay off a bet with Hal Hamrick, the track's public relations manager. Purcell, who provided Bristol its race dates just a few months before, bet Hamrick they wouldn't sell out. What was the price of losing? A new $700 cowboy hat.

Allen's trip to victory lane may have been the only thing more unlikely than the success of the rookie promoters. That's because weeks before the Bristol race, Allen was a driver without a ride. Car owner B.G. Holloway gave Allen's Chevrolet to Ned Jarrett, his other hired driver, to use as a backup and boost Jarrett's championship chances.

"After Atlanta, they decided they couldn't afford to run two cars," Allen said five decades later. "But Ned asked me if I had a ride for Bristol. I said, no. He said I could run the Chevrolet, if it was all right with Holloway, but I would have to come up there to his shop to help get it ready."

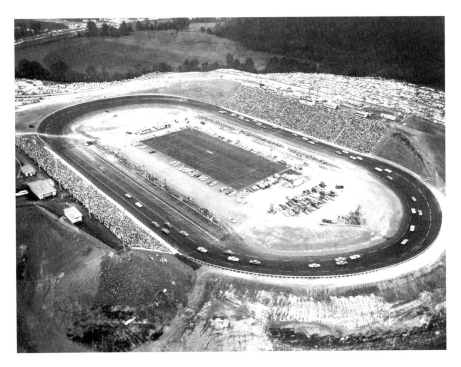

Forty-two drivers roar around the brand-new Bristol International Raceway in the July 1961 Volunteer 500. *Courtesy Bill McKee/Harrison Hall.*

So while Jarrett raced to consecutive third-place finishes on South Carolina dirt ovals in Columbia and Myrtle Beach the weekend before Bristol, Allen worked in Jarrett's Newton, North Carolina garage preparing his former car.

Once in Bristol, Allen's weekend began by qualifying a disappointing thirty-fourth, but that inauspicious start was exceeded only by his spectacular exit. On race day, he completed just one hundred of the race's five hundred laps before the car's rear differential seized. But the fun didn't end there.

"I came in the pits, and the crew was gonna put a new rear end in it, to try and get a good finish," Allen recalled. "They started pulling it down, and one of our guys got overanxious and started pouring gas in the car, thinking that would speed things up. Well, the hot grease caught the gas on fire, and we had a pretty good fire in the pit area. They got it out, but it eliminated any hope of getting back in the race."

But Allen's luck was about to change.

Out on the track, fans watched the field mix it up early and often in the thirty-sixth of fifty-two races on NASCAR's 1961 schedule. Junior Johnson led the first 124 laps before going to the pits because a crash with Joe

Weatherly and Tiny Lund ripped the driver's door off his red Pontiac. There were spins and crashes, but none were too serious. Driver Ken Rush was just shaken up after smacking the front stretch concrete wall and then hitting the inside guardrail, scattering parts of his Ford everywhere. Driver Herb Tillman retired to the pits following his fourth spinout of the day on lap 422.

To keep the fans informed of all that action, Bristol hired noted racing announcer Bob Montgomery and Chris Economacki, the editor of *National Speed Sport News*, to call the race over the public address system. Hamrick thought they might need some help, so he brought in an up-and-coming young radio announcer from Elkin, North Carolina, named Barney Hall, even though Hall had no previous experience broadcasting auto racing.

For those who couldn't attend in person, Carrier, Moore and Pope even organized a regional radio network to broadcast the race. In addition to announcers from local radio station WJCW, the promoters brought in Charlotte Motor Speedway public relations director and Daytona announcer Earl Kelley.

All of them had lots to talk about when hard-charging Junior Johnson stormed back to retake the race lead on lap 180. But he soon gave way to Rex White, NASCAR's 1960 Grand National champion. White stayed in

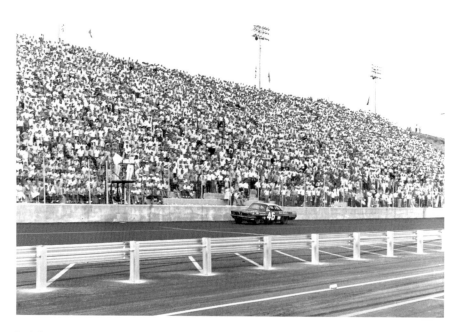

Jack Smith's Pontiac flashes before a sellout crowd at Bristol's first Volunteer 500. *Courtesy BMS.*

front of the pack for just 41 laps before Jack Smith roared into the lead on lap 267. Smith quickly built a 3-lap margin over second place, but the torrid pace was taking its toll.

"The cover over the gearshift cracked and came off, and there was a lot of heat coming in," Allen said. "It was hot that day anyway, and it started burning his foot."

Besides being one the sport's early stars, Smith was a pioneer of using two-way radio communication with his pit crew. He called in and told them to find someone to replace him, and Allen was available.

"I'd driven his car before at Darlington, and we'd raced together," Allen said of Smith. "He had a lead of a couple laps or so when I jumped in the car, and I was still in the lead when I got back on the track. I was able to maintain it the rest of the race."

Maintain may be a bit modest, since Allen actually stretched the margin to six laps ahead of his nearest pursuer before making a late pit stop to change tires.

"They kept trying to slow me down," Allen said of Smith's crew. "But you couldn't slow down too much because the sway bar on the car was broke, and it would wear the tires out."

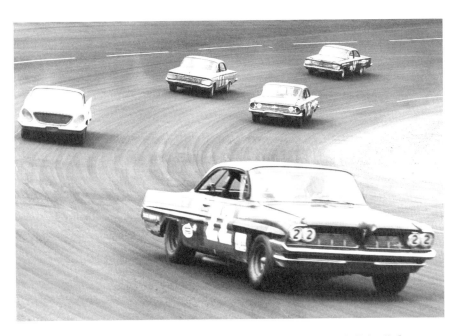

Fireball Roberts *(22)* charges out of turn two. Roberts finished second in Bristol's first race. *Carl Moore collection/John Beach.*

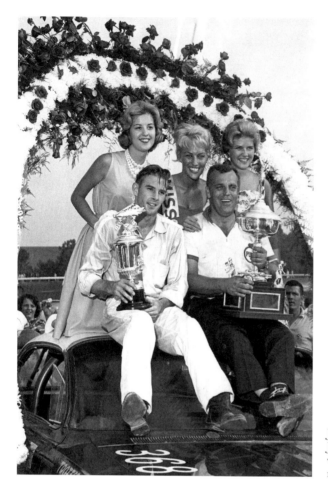

Johnny Allen *(left)* and Jack Smith celebrate winning Bristol's first race. *Carl Moore collection.*

Three hours, thirty-nine minutes and twenty-three seconds after it began, Allen drove Smith's maroon and white Pontiac beneath the checkered flag, two laps ahead of Fireball Roberts in a Pontiac prepared by Smokey Yunick. Ned Jarrett, Allen's former teammate and the reason Allen was even in Bristol, finished third, followed closely by Richard Petty and Buddy Baker.

With the race complete, Allen offered to let Smith celebrate alone. "I wasn't going to go to victory lane. I told him it was his win and his car," the soft-spoken Allen said. "But he said we were going to share this. He was very generous, and he was very generous with the payout with me too." They split a winner's purse of $3,025.

As Allen pulled the car to a stop at the start-finish line, track workers hurriedly placed a horseshoe-shaped display of roses above its roof. Allen

and Smith then climbed onto the car to accept trophies and kisses from the race queens.

Smith told the assembled reporters that he was relieved to get out.

"It was hot out there," Smith said after the trophy presentation. "The oil temperature was around 280 and it was so hot in the car that I think my right foot is blistered."

Decades later, Allen says that Sunday afternoon in Bristol remains one of the highlights of his thirteen-year Grand National career.

What about Carrier, Moore and Pope? Well, after running out of parking space, depleted concessions and a postrace traffic jam, the new promoters had plenty to work on.

"We ran out of everything in the concession stands," Carrier said after the event. "It was unbelievable."

Chapter 4
PERFECT ATTENDANCE

Fred Hayter found it fascinating to watch a race track seemingly rise up out of the ground a few miles south of his hometown of Bristol, Tennessee. He drove by often to monitor its progress, as workers moved tons of dirt, shaped the track, created the grandstands, paved the racing surface and constructed buildings in what seemed like an awfully big hurry.

That's why, on July 30, 1961, Hayter paid eight dollars for a seat near the start-finish line, to take in all of the sights and sounds of the Volunteer 500, the first race at this brand-new Bristol International Speedway.

"I'd never been to a race, but I'd listened to the Indianapolis race and Daytona races on the radio," Hayter said. "I was twenty-one and quite interested. I would ride by to see what they were doing with that hillside. And when they got it finished, I made sure I got to come to the first race. We bought our ticket the day of the race and got a top-row seat."

He and most of twenty-four thousand others plunked down between six and eight dollars apiece to watch forty-two brave men race five hundred laps on a hot east Tennessee afternoon. When the day was over, a sunburned Hayter was hooked on Bristol and stock car racing.

"It was really amazing, watching all those cars go around a little half-mile track," Hayter said. "I remember Jack Smith coming into the pits and Johnny Allen got into the car. It's hard to believe they could do that so fast they didn't lose the lead, but back then pit stops took a lot longer."

Hayter also remembers noting how each car used two people, sitting outside with the fans, to score every lap completed. Fans kept up with the leaders by a sports stadium–style scoreboard located between turns one and

Fred Hayter. *Andre Teague/ Bristol Herald Courier.*

two, where an attendant would hang up the numbers of drivers in the top five positions. Besides, he said, it was nearly impossible to hear the announcers above the roar of the engines.

Hayter also clearly recalls the postrace traffic jam, as fans parked in the meadow between the front stretch grandstands and the nearby creek tried to leave.

"We were parked in behind the 'A grandstand,' and it took three hours to get out of the parking lot," Hayter said. "Of course, we didn't have all the exit roads they have now."

Fifty years later, Hayter can make a claim few if any can match: he hasn't missed any of Bristol's first one hundred races. For a track where fan loyalty is legendary, Hayter makes quite a case for being its most loyal. Others may travel to Bristol from half a world away, instead of fifteen minutes, but track officials believe Hayter is the only person to attend every race featuring NASCAR's top division.

Add in watching about fifty races from NASCAR's other divisions—at an average of two hundred laps each—and Hayter has witnessed approximately sixty thousand laps of competition, and he wouldn't trade a second of it.

Asphalt or concrete, original or high banked and through rain, snow and blazing heat, Hayter and members of his family have been there. Sometimes their seats were metal folding chairs along the front stretch top row, on the old concrete bleachers, the grass-covered hillside that once overlooked turn two and, more recently, in grandstands high above turn four.

"I moved to the second turn where the crossover gate was," Hayter said. "I loved to sit there because it seemed like more action happened right there at the gate. My dad used to come to some races with me, and we would buy one of the cheaper tickets and go up and sit on the bank under some shade trees. You had to get there pretty early to get a good seat, but that was one of the best seats in the house back then."

Racing has long been a family affair for the Hayters. Besides his father, Joy, Hayter's son, Rick, began coming to Bristol when he turned nine, and grandson Miles hasn't missed a Bristol Cup race in more than a decade.

"My son has only missed two Bristol races since 1969," Hayter said. "He's been to around eighty. My grandson started going in 1998, and he hasn't missed one. Between us, we have over two hundred races at Bristol."

But how did something—work, family, job, vacation, illness or another responsibility or distraction—not snap the streak?

"So far, the good Lord has blessed me," Hayter said. "There hasn't been a single thing that stood in the way, so far. We always planned vacations around the races. I always knew when they'd be a year in advance, so it makes it easier to make it part of your lifestyle. I was my own boss, and even if a race was rained out and run on Monday, I managed to be here. Especially when cell phones came out, I didn't even tell work where I was going."

Now retired, Hayter worked as general manager and chief operating office of Bristol Concrete Products and Tri-State Concrete in Kingsport, Tennessee.

His memories are priceless.

Hayter remembers watching Fireball Roberts win in 1963, the No. 27 Dodge of Larry Thomas flying out the track the next year and the 1971 caution-free race where Charlie Glotzbach and Friday Hassler set a race record that still stands. Cale Yarborough leading every lap in the rain-delayed 1973 spring race stands out, as does the first night race in 1978; Dale Earnhardt's first win the following spring; and his last Bristol triumph in 1999, after punting Terry Labonte out of the way.

In between, Hayter pulled for Richard Petty and more recently Jeff Gordon, at the urging of his grandson. He also appreciated the efforts of Wendell Scott.

Poor old Wendell would come screeching into the pits, one of his boys would point to a tire that needed changing and Wendell wouldn't let them change it until he got out and looked at it. I'll never forget another time he came sliding into the pits like he was leading the race. When they got him serviced, he got out, sat on the tires and ate lunch. Then he got back in and took off just a flyin'. That old car was just a smoking. I loved to watch Wendell.

While Fred never considered skipping a Bristol race, he did tire of one winning streak.

"In the '80s, when Darrell Waltrip won seven in a row, that kind of got boring," he said. Ironically, he and his family now have seats in the Darrell Waltrip grandstand.

Over the years, he's visited many other stops on the NASCAR tour but wouldn't trade any for his hometown speedway.

"There's no place like Bristol to see a race because you can see the whole track," Hayter said. "You never miss anything. Bristol is the ideal place for anybody to see a race."

Chapter 5
NOBODY CAME

Situated in the center of Bristol International Speedway, the green grass field with goalposts at each end doubtless sparked plenty of conversation among race fans attending that first Volunteer 500. Beyond the obvious contrast to the recently bulldozed earthen hillsides all around the new track, the 120-yard-long by 160-foot-wide gridiron seemed strangely at odds with an environment of asphalt, steel and gasoline.

The field, created to host major college and professional football games, was the brainchild of track cofounders Larry Carrier, Carl Moore and R.G. Pope. They envisioned it as a way to diversify the operation and recoup some of their substantial investment. Months before, it was Moore who predicted the speedway would become a multipurpose sports facility.

First up, Bristol would host east Tennessee's initial professional football game on Labor Day weekend. It would be an NFL exhibition contest, pitting the defending world champion Philadelphia Eagles against the Washington Redskins.

"The only team you could get on TV around here was the Redskins, so they were big here," Moore recalled. "And the Eagles had won the championship the year before, so we just knew we were going to have a sellout."

Selling thousands of tickets to a football game probably appeared easy for guys who just defied immeasurable odds by building a new race track in six months and then selling out their first Grand National race.

Instead of a victory celebration, they got sacked. Much like Lucy repeatedly humiliates Charlie Brown by yanking the football away just before he kicks, Carrier, Moore and Pope fell flat on their collective backs. Their

BRISTOL
INTERNATIONAL
SPEEDWAY

Presents

PRO-FOOTBALL

STARS OF THE NATIONAL
FOOTBALL LEAGUE

WASHINGTON
REDSKINS

VS.

THE WORLD CHAMPION

PHILADELPHIA
EAGLES

SATURDAY SEPT. 2, 1961
8:00 P.M.

A ticket to the 1961 football game. *Courtesy Graig Hoffman.*

Bristol facility had been filled to practically overflowing just thirty-four days before, with twenty-four thousand race fans crammed into every available space. But when it came to football, they barely scored.

"Nobody came," Moore said. "People told me later they didn't come because they were concerned their seats would be too far away to see the action."

The *Bristol Herald Courier*, the local daily newspaper, generously estimated attendance at 8,500, but Moore claims the real number was substantially less. Newspaper sports editor Gene Thompson described the crowd at "Bristol International Speedway Stadium" as "disappointingly small." He politely reported the highly anticipated game "failed to draw the fan support that had been envisioned for the attraction."

Even in losing seasons, the Redskins typically played before twenty-seven thousand fans at games held at the old Griffith Stadium in Washington, D.C. And just a month after their Bristol appearance, the Redskins opened the regular season by christening the all-new fifty-six-thousand-seat D.C. Stadium, later renamed to honor Robert F. Kennedy.

In Bristol's game, the upstart Redskins led twice in the first half and only trailed the heavily favored Eagles by four points at halftime. The game was briefly interrupted in the second quarter by a bench-clearing fight, but order was quickly restored. Led by quarterback Sonny Jurgensen, who completed nine-of-fifteen passes for 145 yards and two touchdowns, the Eagles came back to win 17–10.

"We were going to try to get other games but not after that first one. We lost $30,000 that night," Moore said. "Larry and I cut the goalposts down ourselves."

Chapter 6
"WORLD'S FASTEST HALF-MILE"

Modern-day Bristol Motor Speedway boldly proclaims itself the "World's Fastest Half-Mile," in three-foot-tall illuminated red letters affixed along its backstretch skyboxes.

It is the short track that races like a superspeedway, and the title is more than honorary. Earned decades ago after a sometimes heated rivalry with a now shuttered track just across the mountain in North Carolina, the designation remains an integral part of Bristol's identity, marketing and legendary fan appeal.

But it wasn't always true.

Once Bristol founders Larry Carrier, Carl Moore and R.G. Pope resigned themselves to building a half-mile track, they immediately recognized a problem. How would they distinguish Bristol from the twelve other half miles that hosted nineteen of the 1960 season's forty-four Grand National races? How could they stand out from that crowd?

Besides pavement, Carrier's original priorities were to be the biggest and best in terms of seating and fan amenities, but he soon realized speed sold tickets. And the fastest half-mile track in the country was about seventy miles away in North Carolina. Formerly known as Skyline Speedway, Asheville-Weaverville Speedway was a blazingly fast, high-banked oval tucked away in the mountains north of town. First paved in 1958, the track regularly attracted crowds of fourteen thousand to watch its exciting action.

At NASCAR's urging, Carrier, Moore and speedway architect Don Rawls visited the track while they were designing the Bristol track, and Carrier immediately liked what he saw.

"Being the fastest was important to Larry," Moore recalled decades later. "It became a priority."

Bristol was designed with twenty-two-degree banked corners, which Carrier believed would offer the speed and excitement he craved. What soon developed was a spirited rivalry between the two race tracks.

At Bristol's January 1961 announcement, NASCAR executive manager Pat Purcell predicted Bristol's track would compare favorably with the flat half mile in Martinsville, Virginia, and the more steeply banked Asheville-Weaverville.

"Drivers should be able to attain a speed of 90 to 100 miles an hour on this new track," Purcell predicted.

The hype heated up before the first car turned a lap of practice at Bristol. Gene Thompson, then the sports editor of the *Bristol Herald Courier* newspaper, became the first to publicly champion Bristol as potentially the fastest half-mile track in America.

"Speeds in excess of 100 miles an hour, something seldom seen on a half-mile track, will be possible as the daredevil drivers gun their souped up cars and battle for positions," Thompson wrote in a column that appeared in the first Volunteer 500 souvenir program.

Bristol's straightaway speeds may have approached 100 miles per hour, but the pole position for that first race was 79.225 miles per hour, by Fred Lorenzen. While that was considerably faster than all of the circuit's half-mile dirt ovals and most of the paved ones, it wasn't *the* fastest. Asheville-Weaverville temporarily retained that distinction thanks to a 79.295 mile-per-hour lap run by Rex White in March 1961.

The average speed of Bristol's first race also fell short. Jack Smith and relief driver Johnny Allen posted an average speed of 68.373 miles per hour in taking the win, but Bob Welborn averaged 71.833 miles per hour when he won a five-hundred-lap race at Asheville-Weaverville in 1959.

Two weeks after Bristol's first race, the Grand National tour returned to Asheville-Weaverville. While that August 13, 1961 event will forever be remembered as the race where fans started a riot and held drivers hostage after the race was shortened, Carrier and company were more concerned that Jim Paschal ran a qualifying lap of 80.43 miles per hour.

In the days leading up to the October 1961 Southeastern 500, Bristol's promoters bought full-page ads in the Bristol newspaper, all but guaranteeing world-record qualifying speeds. And Bobby Johns delivered the goods. Driving a Pontiac owned by Jack Smith, Johns was one of three drivers to better the old track record and, more importantly, steal the crown for Bristol.

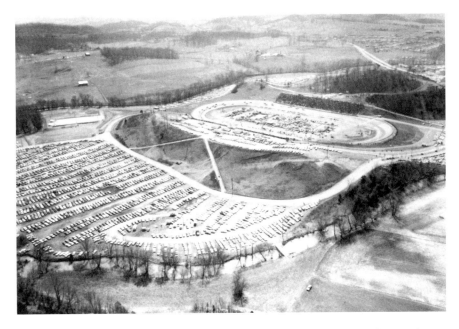

An early aerial look at what was then called Bristol International Speedway. *Courtesy of Charles Earhart.*

His lap of 80.645 miles per hour came on a track that news reports even described as "damp."

That initial Southeastern 500 provided Bristol some additional bragging rights because winner Joe Weatherly set the fastest average speed for a five-hundred-lap race on a half-mile track at 72.452 miles per hour.

But Bristol didn't keep the title for long. NASCAR's 1962 season actually began in November 1961 at Asheville-Weaverville, and on a chilly Friday afternoon, Joe Weatherly raised the single-lap qualifying mark to 81.743 miles per hour.

The rivalry grew intense so quickly that ads for Asheville-Weaverville races weren't included in Bristol's programs after the 1961 season. In the 1962 Volunteer 500 souvenir program, Carrier claimed Weatherly's winning average speed proved "the Bristol course is the fastest half-mile track on the circuit." However, Fireball Roberts won the pole but fell short of the record.

For the next five years, Bristol failed to wrestle the qualifying standard from Asheville-Weaverville, which was promoted by Enoch Staley, a confidant of NASCAR president Bill France.

Darel Dieringer collected a cash bonus for bringing the record back to Bristol at 87.124 miles per hour in winning the pole for 1967 Southeastern

500. Fame again proved fleeting; seven months later, Bobby Allison circled Asheville-Weaverville at 90.407 miles per hour in a Holman-Moody Ford. Bristol's fastest qualifying speed never broke 89 miles per hour during the next two seasons.

Johnny Allen, who raced at both facilities and helped Jack Smith win that first Volunteer 500, remembers there was more to the story. "Bristol wanted to be the fastest half-mile asphalt track in the country, but it wasn't," Allen said. "Asheville-Weaverville was faster, but that was because it was shorter."

An ad in the 1964 Volunteer 500 souvenir program boasted Bristol was the world's "fastest *true* half-mile."

"Bristol was actually a big half mile," Allen said. "NASCAR called both of them a half mile because, back then, anything close to a half mile was a half mile. Bristol didn't like that and said it was unfair, but NASCAR wouldn't recalculate or redesignate, so that's when Bristol put the high bank up. Then there would be no doubt."

Carrier, the former Golden Gloves boxer, threw his knockout punch in the spring of 1969 in a news conference to announce his plan to reconfigure the track:

> *We are going to bank the straightaways 20 degrees, with the banking becoming progressively higher as cars head into the turns. The beginning part of the turns will be banked 31 degrees, with gradual increases to 35 degrees at the steepest part of the turns. Engineers tell us that the race cars will have to run mighty fast through the turns just to keep from falling off. We have no doubt that we will be the fastest half-mile track in the world.*

With a sly smile, Carrier boldly predicted straightaway speeds would hit 140 miles per hour.

Thirty-five degrees of banking? Not even the turns of Daytona's mighty two-and-a-half-mile superspeedway were that steep.

"Through extensive study of other tracks who claim to be fastest in the world—those both in the north and south—we're finding that they are banked higher," Carrier said. "The Goodyear tire people feel we should not make the track any higher, but we feel that this is what the public wants."

The extensive rework began on May 18, 1969, the day after Bristol hosted an Automobile Racing Club of America race, and was completed in mid-July. When NASCAR drivers arrived for the Volunteer 500, they were awestruck by the difference, as the guardrails seemed to hang out over the steeper track surface.

Cale Yarborough blasted the Wood Brothers Mercury to the race pole with a previously unheard of 103.432 mile-per-hour lap that was 13 miles per hour faster than Asheville-Weaverville's record and 15 miles per hour faster than any lap ever run at Bristol. Right behind Yarborough, the next seven cars all topped 100 miles per hour. When qualifying ended, J.D. McDuffie was the only one of thirty-two starters who didn't exceed both the Bristol and Asheville-Weaverville track records. David Pearson received relief help from Richard Petty to win that Volunteer 500.

Just like that, the rivalry ended. Now the site of North Buncombe High School, Asheville-Weaverville hosted its thirty-fourth and final NASCAR Grand National race thirty-six days after Bristol's first high-banked contest. While its official cause of death was encroachment by residents and businesses complaining about noise, the old Asheville-Weaverville track may have simply lost its will to continue.

Chapter 7

FORGOTTEN 500s

Ramo Stott couldn't believe his eyes. Less than a day after taking the checkered flag in the rain-shortened Tennessee 500 at Bristol International Speedway, a swarm of workers had descended on the half-mile racing surface. Stott and his crew stopped by on their way back to Iowa and found them reconfiguring the track to add steeper banking all the way around, with less than two months to get the job done.

In addition to being the last race on the original Bristol surface, the Tennessee 500 was the second and final time the Automobile Racing Club of America would visit Bristol. Dampened by poor weather and worse attendance, Bristol hosted two somewhat spectacular but nearly forgotten races on the series's 1969 schedule.

Based in Toledo, Ohio, ARCA teams competed primarily on midwestern short tracks, except for annual visits to giant superspeedways in Daytona Beach, Florida, and Pocono, Pennsylvania. Their cars were full-size sedans, similar to those found in NASCAR, so Bristol promoters Larry Carrier and Carl Moore reasoned that, if the series was good enough for Daytona, it might play well in Bristol.

Run in 1968 and 1969, neither installment of the Tennessee 500 reached its advertised distance, as rain and snow wreaked havoc on competition and spectator turnout. Plans for a third Bristol race were canceled.

Despite its shortcomings, Bristol's final ARCA event is notable because it represented the first series victory for Stott, who went on to claim two ARCA championships and become a regular on NASCAR's Grand National circuit. But Bristol's first ARCA event was memorable for other reasons.

ARCA drivers first arrived in Bristol in early November 1968 for what was actually the third scheduled race of their 1969 season. Only the top ten qualifying spots were filled on November 8, and rain prevented any more on-track activity that weekend. The cars were fast, as Les Snow raced his Plymouth to the top qualifying spot with a lap of 85.106 miles per hour—quite respectable, considering Richard Petty held Bristol's NASCAR qualifying record at that time at 88.582 miles per hour.

Kentuckian Andy Hampton posted the second-fastest qualifying lap in a black and gold Dodge owned by H.B. Ranier, while newly crowned 1968 ARCA champion and future NASCAR star Benny Parsons qualified third. Hampton's teammate, Bobby Watson, qualified fourth in a Dodge formerly driven in NASCAR by Paul Goldsmith and sponsored by Valleydale meat packers of Bristol, Virginia. It was the same car Goldsmith used to lead 154 laps in that summer's Volunteer 500 at Bristol, and the NASCAR driver came along to help set up the chassis.

A light drizzle fell through much of the next weekend, but the hearty ARCA drivers were still able to complete 211 of the scheduled 500 laps. Parsons and Watson exchanged the lead, with Watson retaking the top spot on lap 153 when Parsons made a pit stop. ARCA officials threw the race's

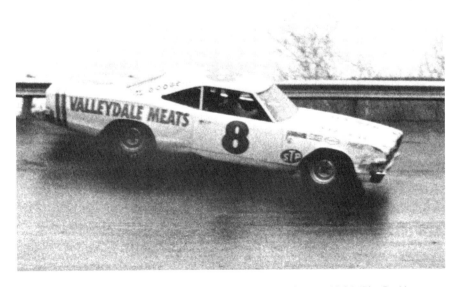

Bobby Watson spun but still won the rainy Tennessee 500. *Courtesy ARCA/Tom Davidson.*

first caution flag when Jesse Baird spun on a wet turn two but displayed the green again on lap 172 despite deteriorating conditions. Race leader Watson promptly spun out in the third turn.

"I looped it four or five times, never hit anything and never lost the lead." Watson recalled. "It was plenty interesting."

In the melee, Parsons sustained fender and tire damage by clipping Watson's spinning car, but he remained on the track in second place.

The caution flag reappeared on lap 181, and drivers circled the track behind the pace car until lap 211. When the rain intensified, officials stopped the action with Watson two laps ahead of Parsons, but 39 laps short of halfway and an official race.

Teams returned to Bristol to try and complete the event on November 24 but received some unprecedented news. ARCA president John Marcum decided to split the event in half and crown Watson the winner of the "first half." Marcum planned to pay out half of the purse money and full points for the previous week's finish and the balance of the money and complete points for those competing in the 250-lap "second half."

"John did stuff like that," Watson said when reminded of the plan.

After driving hundreds of miles just to get back to Bristol from all over the Midwest, the drivers agreed to run what was essentially a new race. But snow and rain prevented the first car from getting onto the track.

Watson got credit for the third of his twenty wins in a stellar ARCA career and it certainly ranks among the most memorable. The points earned, despite being half of what a full race offered, helped propel Watson to a second-place finish in the 1969 ARCA series standings behind repeat champion Parsons and ahead of Stott.

"I really liked the old Bristol," Watson said of his favorite track. "Seems like I could really get around there good, but you know I never did get the trophy for that win. I guess they forgot about it when it snowed that next weekend."

Marcum and Carrier tried again the following May but were soon reminded that it also rains in the springtime. The final Tennessee 500 was stopped by rain after 412 laps, with Ramo Stott the runaway winner in his first Bristol visit.

Stott, whose reputation was forged dominating midwestern dirt tracks, took the lead on lap 150 when Benny Parsons brought his Ford to pit road. Stott's lead ballooned when Parsons pitted again on lap 320. When Parsons returned to the track that time, he suffered a flat left front tire that ruined any hope of a comeback.

Bobby Watson. *Courtesy ARCA*.

The only thing that could stop Stott was running out of gas—which he did twice. But both times he was able to coast down pit road and refuel. Stott's ten-lap winning margin over second-place Andy Hampton is the largest in Bristol history.

"My car handled real well and I think I had it set up real well for this race," Stott said in his postrace interview. "My shoulder bothered me some because it gets pretty tense out there, but this is my first victory this season and I feel pretty good about it."

Decades later, Stott admitted he was apprehensive about racing at Bristol because of the track's reputation for chewing up race cars.

"I'd run a few half miles, but I knew everybody came out of Bristol in wrecks," Stott said. "But I figured if I was going to run ARCA, I'd have to go."

Parsons was credited with third place despite a nightmarish day that included needing relief help from crew chief Ralph Young, and Watson escaped a crash with fellow Kentuckian Baldy McLaren to finish fourth. Fourteen of twenty-six cars were running at the finish, and a crowd generously estimated at six thousand witnessed the event.

Ramo Stott. *Courtesy ARCA/Tom Davidson.*

Stott didn't even have to spend any of the winner's check to feed his crew that night, thanks to a friendly wager with a stranger.

"We stopped in this little restaurant on the way to the track that morning," Stott recalled decades later. "The owner asked us who we thought would win, and one of my crew guys said, 'Ramo.' Well the guy says, 'Oh no, Benny Parsons is gonna win it.' So my guy bets him that we'll win it. I guess he was basing it on Benny Parsons being the champion, and he didn't know me from Adam. So he bets dinner for all of us. After we won and loaded up, we went back there, and that guy cooked steaks for all us—really nice guy."

Chapter 8

CAUTION FREE

The sport's most talked-about car, Junior Johnson's refrigerator white Chevrolet Monte Carlo, sat idle in the Bristol pit area. While Richard Petty, Bobby Allison and two dozen others used a three-hour morning practice session to try and perfect their setups for the next day's 1971 Volunteer 500, Johnson, crew chief Herb Nab and driver Charlie Glotzbach parked their one-of-a-kind racer.

Johnson, who was still sorting out longevity issues with the unique 427-cubic-inch power plant, reasoned there was no need to run unnecessary laps.

"After we qualified the car second fastest, and after running a few laps of near eighteen-flat [seconds], we felt the car was ready," Johnson said. "And we didn't want to take any chances. We only had to make a few minor adjustments and the car was ready."

Glotzbach knew the engine was a time bomb.

"It was real fast, but it had a lot of valve train problems," Glotzbach said decades later. "Once they got that worked out, it ran good."

Skipping practice also prevented other contenders from measuring themselves against the speedy Chevy adorned with the same red and gold leaf stripes and shaded red number threes that Johnson used on his iconic "mystery motor" 1963 Impala. That car helped cement the reformed moonshiner's legend nearly a decade before, and this one was about to write a whole new chapter.

Bristol's July race represented only Johnson's third outing since returning to the Grand National series, a product of Ford's sudden pullout from racing after the 1970 season. His jump to General Motors was the brainchild of

Richard Howard, the portly personable president of Charlotte Motor Speedway who reasoned a competitive Chevrolet would sell tickets to his World 600.

So in April 1971, Howard called Johnson with a proposition: Howard would pay for Johnson to build and drive a Chevrolet in Charlotte's Memorial Day weekend race. After five seasons out of the cockpit, Junior agreed to build the car but declined to drive; he opted instead to hire Glotzbach, whose "Chargin' Charlie" nickname aptly described his flat-out driving style. Together they put Howard's Chevrolet on the pole position for his Charlotte race. The car was fast enough for Glotzbach to lead four times that day before crashing. For his investment, Howard got a nice bump in attendance with fans curious to see Junior's *"Shevalay"* race against the Fords and Chrysler products.

Based on their success, Howard and Johnson decided to only race when a promoter would pay them $10,000, substantial appearance money in an era where a typical short track race winner made $5,000 or less and speedway races paid between $15,000 and $30,000 to win. After rebuilding the Monte Carlo, their next outing was Independence Day weekend in Daytona Beach, Florida. Glotzbach qualified third fastest for the Firecracker 400 but blew the engine after just forty-three laps.

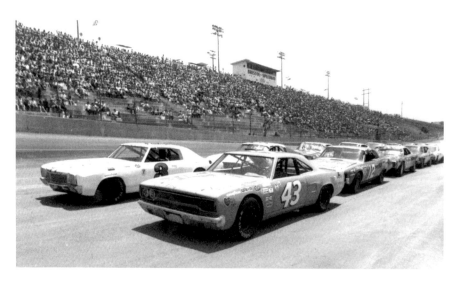

Richard Petty *(43)* and Charlie Glotzbach comprised the front row for a caution-free 1971 Volunteer 500. *John Beach.*

The team arrived in Bristol five days later, and Glotzbach wasted no time clocking the second-fastest lap during Friday's qualifying session, earning a front-row starting spot for the Volunteer 500.

After agreeing to invest the $10,000, Bristol speedway president Larry Carrier tried to beat the prerace publicity drum.

"With the strong showing from the Chevrolets in today's race, this should be a real competitive one," Carrier told the news media.

Truthfully, Bristol needed a competitive race. Just ten of thirty cars were running at the end of that spring's Southeastern 500. Since reconfiguring the track with higher banking in July 1969, four other Bristol races were won by an average margin of three laps.

"I was real happy for Charlie Glotzbach," Carrier told the media. "And I'm sure the Chevrolet fans are too that Junior Johnson, the old racing master, has prepared such a competitive car."

It was competitive alright—competitive enough to run away and hide. When the green flag waved just after one-thirty on Sunday afternoon, Chargin' Charlie made the field believe the white Chevy was a ghost. Teamed with relief driver Friday Hassler, they made a shambles of the Volunteer 500, posting the fastest race-winning average speed in Bristol history at 101.074 miles per hour—a mark that still stands forty years later.

Why so fast? The entire five hundred laps were run without a single caution flag.

"I don't think that will ever happen again," Glotzbach said on the eve of the track's golden anniversary. "Back then, we didn't have all the caution flags they have now. If we had five cautions in a race, that was a lot. But they improved the track a lot when they redone it a few years ago, and they don't have as many wrecks as they did at one time."

Glotzbach and Hassler teamed to lead 411 of the day's 500 laps, beating the second-place car by three laps.

"It was a good day," Glotzbach said. "Some days you can't do anything right, and some days you can't do anything wrong. That was a day we couldn't do anything wrong. Back then, Junior used the same shock setup and springs at Bristol as he did at Daytona. That's why the car ran so fast. It was really fast everywhere we ran it."

Glotzbach's only scare occurred just after a midrace pit stop when he tangled with John Sears's Dodge. There was no caution flag, but Glotzbach was forced to pit again, and that time gave way to Hassler.

"I'd hurt my neck in that wreck in Charlotte," Glotzbach recalled. "It got to hurting, and I told them to find me somebody, and he was available.

I could have gotten back in, but he was doing good, so I told Junior to just let him finish it."

The Glotzbach-Hassler exchange allowed Bobby Allison to briefly take the lead, but Hassler retook the top spot when Allison pitted to get relief help from James Hylton. Hassler and the combination of Hylton and Allison exchanged the lead four more times before the Chevy took over for good on lap 357. Hassler, who had actually practiced a few laps in Johnson's car earlier in the weekend, then built a substantial lead, prompting Johnson to display the "E-Z" message on the team's pit board.

"We slowed Friday down with about a hundred laps to go," Johnson chuckled.

Hassler finished three laps ahead of second-place Allison, although Hylton was actually driving Bobby's car at the finish. Richard Petty finished third,

Charlie Glotzbach *(left)* and relief driver Friday Hassler celebrate a record-setting victory. *John Beach.*

six laps down, after switching out several times with relief driver Buddy Baker. Hylton's Ford was still running at the end, as his relief driver G.C. Spencer brought the car home fifth. Among the top five, only fourth-place finisher Cecil Gordon didn't require a relief driver.

"It took me about three laps to get used to the car but after that it was clear sailing," Hassler said after his lone visit to a Grand National victory lane. "It was a beautiful car."

To put their accomplishment into perspective, the race was completed in just two hours, thirty-eight minutes and twelve seconds, or about twenty minutes less than a modern five-hundred-lap Bristol race. The average winning speed was nearly ten miles per hour faster than Bristol's previous race record set by David Pearson. And in seventy-eight subsequent races, Cale Yarborough's 1977 Southeastern 500–winning performance is the only other time a Bristol winner has averaged more than one hundred miles per hour. Two cautions slowed that race for nine laps.

Glotzbach's win was Chevrolet's first at Bristol after ten seasons and twenty-one races, the first in NASCAR's top division since 1967 and the first at a major track since 1964. Promoters at the time claimed that having a competitive Chevy brought thousands of extra fans through the turnstiles, but that wasn't the case at Bristol. A crowd of 20,500 was actually about 2,000 less than the previous year.

Chapter 9
FLAG TO FLAG

Cale Yarborough couldn't believe his luck. The raindrops that threatened but didn't fall throughout the morning were now soaking Bristol International Speedway, just as he was pulling away from the field of the 1973 Southeastern 500.

Four races into his full-time return to the NASCAR Winston Cup Series, Yarborough and Junior Johnson had their red and white Kar-Kare Chevrolet set on kill. After thirty-nine laps, Yarborough led second-place Coo Coo Marlin by three-quarters of lap and already had much of the field one or more laps down. After circling the track under caution for thirteen laps, flagman John Bruner Jr., displayed the red flag. Drivers pulled their cars single file onto the track apron, climbed out and waited. The race would be completed in two weeks.

Yarborough had experienced a rocky return to stock cars after racing the open-wheel circuit. He replaced Bobby Allison, who left the coveted seat of Chevrolets fielded by Junior Johnson and Richard Howard, but mechanical problems caused poor finishes in the first two races of the 1973 season. A broken transmission sidelined Yarborough early on the road course at Riverside, California, in January. A month later, Yarborough led twenty-five early laps of the Daytona 500 before engine problems spoiled his day.

The team seemed to hit its stride on the short track at Richmond, Virginia, where Yarborough qualified sixth and finished third after leading 151 of the race's 500 laps.

After two weeks off, the tour hit Bristol's high-banked half mile, and Yarborough started his weekend by shattering the track record with a 107.608 mile-per-hour lap that was 1.7 miles per hour faster than second-

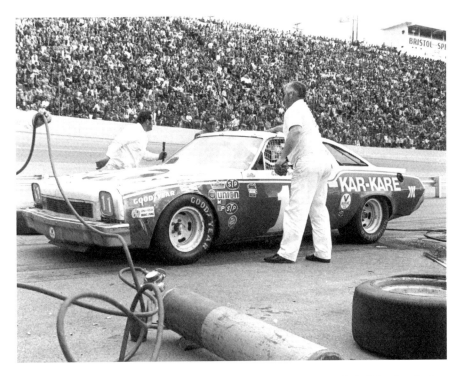

Junior Johnson oversees service of Cale Yarborough's car, as the team led all five hundred laps to win the 1973 Southeastern 500. *John Beach*.

place qualifier Cecil Gordon. But it was a fast field, as all thirty cars qualified at more than 100 miles per hour for the first time in Bristol history.

"We knew we had a quality field," speedway president Larry Carrier said when time trials were complete. "But these qualifying speeds even exceeded our expectations. This should be one of the best races we've ever had."

Between the Bristol weekends, NASCAR regulars ran the Carolina 500 at Rockingham, North Carolina, and the Yarborough-Johnson team brought its Bristol car to the larger, faster 1.017-mile speedway. Yarborough finished second behind David Pearson, who led all but 1 of 492 laps in the Wood Brothers Mercury.

Perhaps inspired by Pearson's heroics, Yarborough and Johnson brought that same Chevrolet back to Bristol and reassumed their spot at the front of the pack. Behind him, Coo Coo Marlin, Bobby Isaac, Richard Petty, Bobby Allison and Cecil Gordon were the only others on the lead lap.

When the green flag reappeared on March 25, Yarborough did Pearson one better: he led every single lap en route to his first Bristol victory.

Afterward, the driver gave all the credit to Johnson and mechanic Herb Nab.

"I've never had an easier ride before. Not ever," Yarborough told the assembled news media. "I've been fortunate to have driven some fine race cars down through the years, but I've never had this smooth a ride over this long a race. When that happens on a short track, that's something else. Herb, Junior and the boys did a fantastic job of setting up the car. I had no problems and could run anywhere on the track—high or low."

Yarborough said "everything" went perfectly, and his only close call occurred after the race's seventh and final caution, when David Sisco's Chevrolet spun out just in front of him.

"This is the longest I've ever led a race," Yarborough joked. "I held the lead in this one for two weeks."

An unscheduled pit stop took Richard Petty out of contention for the win, but he still finished second, two laps behind. Bobby Allison was third, five laps off the winner's pace. Marlin had been running fifth on lap 229 when Buddy Baker's Dodge slammed the third-turn guardrail, briefly caught fire and then collected Marlin's Chevy. After making repairs, Marlin finished 24 laps down in sixth place.

The flag-to-flag win was the first, most dominant of the nine Yarborough racked up at Bristol during a remarkable eight-year, sixteen-race span. Yarborough remains the only driver in one hundred Bristol races—and the only one in modern NASCAR history—to lead all five hundred laps.

Chapter 10

A HELPING HAND

John A. Utsman was surprised when Winston Cup series points leader Benny Parsons inquired about his weekend plans during a Friday morning Bristol practice session.

A Late Model Sportsman standout that had started just three Cup races, Utsman didn't have a ride for the 1973 Volunteer 500. He was just another spectator at his hometown track when he ambled over to watch Parsons and crew chief Travis Carter prepare their car.

"What are you doing Saturday?" Parsons asked after recognizing Utsman.

"Nothing," he replied.

"Well why don't you bring your driver's suit and helmet tomorrow and try this thing out," Parsons offered, pointing toward his bright orange L.G. DeWitt-owned Chevrolet. "I might need some help Sunday."

Utsman barely knew Parsons, a two-time Automobile Racing Club of America champion. But when the sport's top-ranked driver offers seat time, even for practice, it's not an opportunity to turn down.

The next morning, Utsman donned his white uniform, with the large Goodyear patch on the back and his name embroidered on the front, and made six practice laps in a car Parsons already qualified second fastest for Sunday's race.

The calculating Parsons knew July afternoons could be brutal roaring around the Bristol oval. He figured Utsman would be a great insurance policy to help maintain his points lead at a track where anything could, and often did, happen. Utsman had captured the previous season's NASCAR Late Model Sportsman championship at nearby Kingsport Speedway by

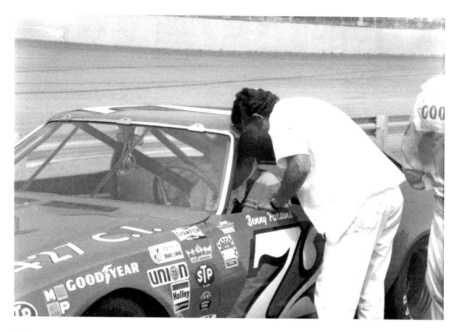

John A. Utsman settles into Benny Parsons's Chevrolet during practice for the 1973 Volunteer 500. *Mike O'Dell.*

beating many of the Southeast's best drivers and finished tenth in Bristol's 1973 Southeastern 500.

"I didn't really much more than know Benny, and he didn't know me either," Utsman said. "But the third lap I run was fast enough to sit on the pole. That thing drove so good."

Cale Yarborough, one of five drivers in contention for the 1973 championship, would be the other prerace favorite. He'd dominated that spring's Southeastern 500 and qualified Junior Johnson's Chevrolet on the Volunteer 500 pole.

When the green flag waved, Yarborough jumped ahead, but Parsons soon powered past and roared away. After leading much of the race's first half, Parsons radioed his crew to get Utsman ready. Parsons gave up the lead to pit on lap 250 and crawled out of the passenger side window opening while Utsman climbed in. After buckling his safety harness, Utsman sped onto the track in third place.

"You know how Cale Yarborough won that first race and led all 500 laps?" Utsman asked. "Well the first thing I saw, when I straightened that mirror up in Benny's car, was Cale Yarborough right behind me. He stuck his nose up beside me a time or two in traffic, but I could just drive off from him. That was a thrill."

At that moment, Utsman and Yarborough were both trying to chase down leader Bobby Allison. The winner of both 1972 Bristol races, Allison paced the field until he and Yarborough pitted simultaneously on lap 332. About 8 laps later, something broke on Allison's Chevrolet as it sped down the backstretch. His car shot up the track, and Yarborough, who went high to try and avoid him, slammed into Allison's car, eliminating both from competition.

In that moment, Utsman went from a two-lap lead to a four-lap cushion over new second-place runner L.D. Ottinger. After 180 laps behind the wheel, including many at the front, Utsman brought the car back down pit road so Parsons could finish the run. The winners wound up with a seven-lap margin over second-place Ottinger, another talented east Tennessean making just his second Winston Cup start.

"I think John did a wonderful job in the car," Parsons told reporters after the race. "He's a driver who keeps his nose out of trouble. I've seen him drive at other tracks and I knew he could do the job."

The win was Parsons's lone victory during his 1973 championship campaign. Combined with Yarborough's poor nineteenth-place finish, Parsons's Bristol win awarded him enough points to eventually withstand a late season charge by Yarborough and claim the championship.

While historians point to the dramatic comeback Parsons made with a wrecked race car in the 1973 season's last race at Rockingham, North Carolina, that final act was set up in Bristol when Utsman and Parsons raised the Bristol trophy.

"The biggest thrill I ever got was when Benny asked me to relief drive for him, and we won that race," Utsman recalled. Among his most prized mementos from a successful racing career is a handwritten letter from Parsons, thanking him for their 1973 win.

"If I'd wrecked he wouldn't have won the championship," Utsman said. "So I was part of the championship, even though I don't get credit for it, which is fine with me. Benny just done me a big favor, and I done him one by taking care of his car."

Chapter 11

UNDER THE LIGHTS

In post-Vietnam America, motorsports found itself surrounded by a funk. The nation's economy slowed, gasoline shortages prompted long lines at the pumps and American automakers had all but forsaken racing. Detroit assembly lines that once spewed out muscle cars with throaty V-8 engines were producing smaller cars and smaller engines to meet demands for better fuel economy and emissions.

Race attendance everywhere lagged and many tracks experienced short fields. As the 1970s wore on, Bristol certainly wasn't immune. The gamble with higher banking produced greater speeds, but Cale Yarborough and car owner Junior Johnson seemingly owned the keys to victory lane. Compounding that problem, weather for Bristol's spring race was often bitterly cold, and their summer race was all too often a sauna for both drivers and fans.

Bristol's announced attendance at both 1974 races was twenty thousand. To try and escape the brutal July heat, promoters Larry Carrier and Carl Moore got the 1975 Volunteer 500 date switched to early November, but only about thirteen thousand fans showed up. In response to the nation's energy crisis, both 1976 races were shortened to four hundred laps, and Bristol's attendance shrank to seventeen thousand in March and twelve thousand on yet another different date in late August.

For 1977, shifting the spring race to April produced warmer temperatures and a jump in attendance. But driver Cale Yarborough and car owner Junior Johnson stunk up the show, winning by seven laps. Yarborough won again that August, as attendance plummeted to twelve thousand. Since a majority

of tickets were sold on race day, the ninety-degree afternoon temperatures and a threat of showers kept many fans away at a time when the payouts continued rising.

"Back then, there was no point fund to amount to anything, and there was no TV money," Moore said. "We had to go to other races and sign contracts with drivers guaranteeing them appearance money—tow money they called it. Well, after a while, I told Larry we just can't keep doing this. We had notes at banks all over town."

Carrier, who promoted races by stapling fliers to telephone poles across a five-state area, reluctantly agreed. They let it be known Bristol was for sale, and it wasn't long before the telephone rang.

Gary Baker and Lanny Hester were a couple of Nashville entrepreneurs, partners in a series of kidney dialysis clinics, with a love for auto racing and

Lanny Hester *(seated)* signs the agreement, buying Bristol's speedway from Larry Carrier and Carl Moore. *BMS Collection.*

some magnificent dreams. The duo jumped at the chance to own Bristol, completing the deal over the telephone without even inspecting the facility. They came to Bristol and signed the papers on December 1, 1977.

In a statement authored by then track PR man Ed Clark, Hester said:

> We want Bristol fans to know there is a new movement under way at the Bristol International Raceway. We are going to have a better field of cars than have been present in the past and more prize money as well. But we are not going to stop there. Our track is going to be a clean entertainment place for the entire family to come and enjoy a good time together. We intend to be known as a family track.

Plans included repairing damaged concrete grandstands, adding a camping area, an electronic scoreboard and new, clean restrooms.

"I see no reason why we can't have the best show in NASCAR racing on the best track on the NASCAR circuit," Hester said. "That is what we are working for, and we won't stop working until we reach that goal."

Then they made another announcement: the August race would be run on Saturday night instead of Sunday afternoon. Baker, an attorney and accountant to country music stars like Johnny Cash and Waylon Jennings, admits it was a bold decision.

"Basically everybody we talked to said we were crazy," Baker said. "They told us not to even think about running a Cup race at night because you can't do it. We talked it over and said, 'What do we have to lose?' We couldn't give away tickets as it was. Lights were a big experiment, but we saw instant success."

It also wasn't an easy sell to NASCAR, which fancied itself the NFL of auto racing, meaning races were run on Sunday afternoons. At that time, only the Nashville Fairgrounds speedway, also owned by Baker, ran its Cup races on Saturday nights.

"[Bill Jr.] France always told me late-model sportsman cars are Saturday night cars, and Cup cars are Sunday cars," Darrell Waltrip said. "He felt the Cup series was supposed to race on Sunday afternoon."

After installing some temporary lights to supplement the track's rarely used original lighting, Bristol ushered in something that would revolutionize the sport. It was more comfortable for drivers, crews and fans, plus it gave the promoters a built-in rain date. The announced attendance of thirty thousand for the 1978 Volunteer 500 more than doubled the previous year's event.

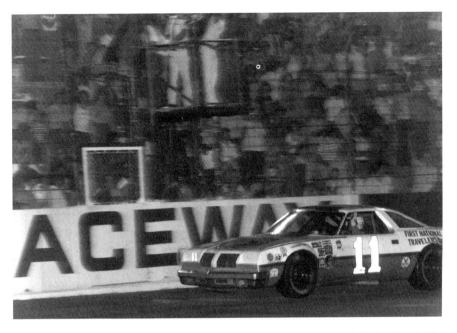

Cale Yarborough claimed Bristol's first night race in August 1978. *BMS Collection / David Allio.*

"We saw real quick all we had to do was keep building seats, and the fans would keep coming," Baker said.

Drivers like Waltrip embraced the change.

"You take Bristol or Nashville, running in the summer time in the afternoon, you could barely stand to work on your car let alone try to race," Waltrip said.

"It was a great hit with the fans," Waltrip said. "We're used to it now, but in the beginning, it just looked so much better; it was more exciting, and the cars looked so much faster. You could see the sparks and fire flying out from under the cars and see stuff you couldn't see in the daytime. So it added an element of excitement to the races people hadn't seen. It was a great idea, and of course, it's caught on pretty well too."

Yarborough beat Benny Parsons and Waltrip in that first Saturday show and promptly pronounced night racing the "best thing since axle grease."

Longtime fan Fred Hayter said the initial night race made quite an impression. "It wasn't lit too good," Hayter said. "The fans could probably see better than the drivers on the track, but it was quite exciting."

Building on that success, Baker and Hester watched attendance continue growing as they invested in infrastructure and grandstand improvements.

"We could tell the interest in our sport was starting to explode, so we knew we had to get in front of it and stay in front," Baker said.

Hester left the speedway partnership in January 1981, and Baker took on two partners for that year before becoming the sole owner entering 1982. But another turning point was on the western horizon.

Warner Hodgdon, a millionaire California industrialist and developer, was putting his stamp on NASCAR racing through race and team sponsorships. Hodgdon's investment in racing grew significantly in April 1982, when he purchased 50 percent interest in Bristol and later half interest in the Nashville speedway.

Bristol experienced its first sellout in many years that August, beginning a remarkable streak that would ultimately transcend three decades. But Baker and Hodgdon clashed often, primarily over Baker's desire to forsake the historic old Nashville short track and build a massive superspeedway outside the city.

Their agreement included a put-call option that allowed one partner to offer to buy out the other after the partnership lasted one year. Frustrated over the Nashville situation, Baker offered to buy Hodgdon's 50 percent for $2 million. But their contract also included a provision to flip the offer, allowing Hodgdon to buy out Baker at his suggested price, which Hodgdon executed in the months following Bristol's May 1983 race.

A "sick puppy" for losing his beloved Bristol, Baker said he couldn't return for years and refused to even listen to Bristol races on the radio.

"A lot of people don't understand what happened here," Baker said. "Bristol was the first track where people really started printing counterfeit tickets and scalping tickets. I still remember clearly when police brought me the counterfeit printer. That was how valuable our August night race had become."

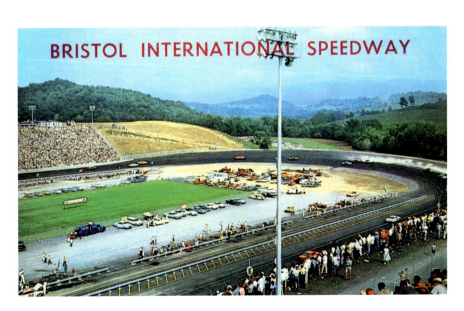

Postcard of turns one and two, during the 1961 Volunteer 500. *Author's collection/Joyce Haynes.*

Postcard of turns three and four, plus the football field, during the 1961 Volunteer 500. *Author's collection/Joyce Haynes.*

This page and next: Souvenir program covers from three landmark events: Bristol's first race in July 1961, the first night race in August 1978 and the first race for NASCAR's new generation race car in March 2007. *Author's collection.*

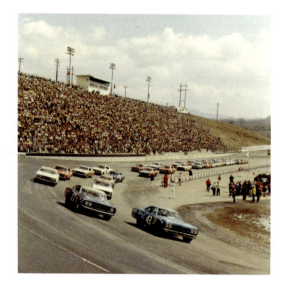

Left: Richard Petty and David Pearson lead the field for the 1968 Southeastern 500. *Courtesy Carl Moore collection.*

Below: Darel Dieringer *(22)* tries to hold off Cale Yarborough *(21)* and Richard Petty *(43)* in the 1968 Southeastern 500. *Courtesy Carl Moore collection.*

Dale Earnhardt celebrates his first NASCAR Winston Cup victory at Bristol's 1979 Southeastern 500. *Bristol Motor Speedway collection.*

Darrell Waltrip captured his seventh straight Bristol victory in the 1984 Valleydale 500. *David McGee.*

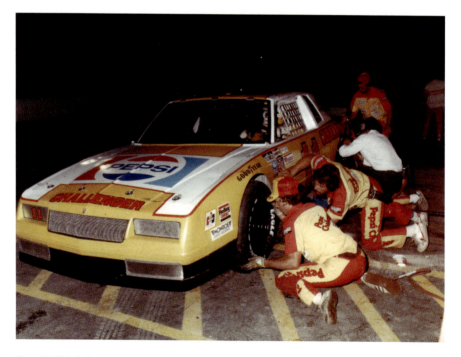

Darrell Waltrip's crew services his Chevrolet in the 1983 Valleydale 500, the only spring night race. *BMS collection.*

Before Bristol's pit entrance was reconfigured, teams parked their haulers outside the track. *David McGee.*

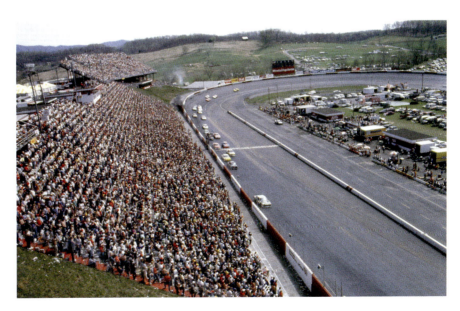

Pole sitter Harry Gant leads the field across the stripe during the 1987 Valleydale 500. *David McGee.*

Alan Kulwicki celebrates his 1991 Bud 500 win, the first of two straight victories at Bristol. *BMS collection.*

Dale Earnhardt *(3)* and Terry Labonte *(5)* race to the white flag in the 1999 night race. *BMS collection*.

Dale Earnhardt *(3)* won the 1985 Valleydale 500 despite power steering failure. Here he passes Rusty Wallace on the high side. Bristol Herald Courier.

Bristol fans established a Guinness World Record in 2007, as 160,000 completed this prerace card stunt display. *Earl Neikirk/*Bristol Herald Courier.

Car owner Jack Roush rebuilds the carburetor of Mark Martin's Ford in 1990. Roush's teams have captured ten Cup wins and five in the Nationwide Series at Bristol. *David McGee*.

Bill Elliott's lone NASCAR short track win was the 1988 Valleydale 500 at Bristol. *BMS collection*.

Rusty Wallace celebrates his fiftieth career NASCAR victory at Bristol. Bristol Herald Courier.

Despite three wins, Richard Petty never considered Bristol among his favorite tracks. *David McGee*.

Nine-time Bristol winner Dale Earnhardt climbs into his car. *David McGee.*

Ernie Irvan *(right)* talks with engine builder Runt Pittman. Irvan and the Morgan-McClure team got their first win at Bristol in 1990. *David McGee.*

Jeff Gordon captured four straight wins in the Food City 500 from 1995 to 1998. *BMS collection.*

An early crash ruined the Bristol Cup debut of Dale Earnhardt Jr. *(8)* in the 2000 Food City 500. Michael Waltrip *(7)* finished eleventh. Bristol Herald Courier.

A year after this crash eliminated Elliot Sadler, he gave the Wood Brothers their first Bristol victory. Bristol Herald Courier.

Jeff Byrd greets the sellout Bristol crowd. *Earl Neikirk*/Bristol Herald Courier.

Jeff Burton *(right)* reacts to a story by BMS owner Bruton Smith during Food City Race Night. *Earl Neikirk*/Bristol Herald Courier.

Chapter 12
"ANYBODY BUT WALTRIP"

Darrell Waltrip looked up at the grandstands, smiled and waved, as Bristol public address announcer Barney Hall introduced him to the sellout crowd. The response was a chorus of boos from fans, many wearing "Anybody but Waltrip" T-shirts or carrying signs displaying similar sentiments.

Everybody loves a winner until he wins too much. Darrell Waltrip won Bristol in every conceivable way, and some despised him for that success. The driver known as "DW" and "Jaws" dominated. He came from behind, he outlasted and once, with a little help from his pit crew and a timely thunderstorm, he stole one from Dale Earnhardt.

During one amazing period, Waltrip and car owner Junior Johnson laid waste to the competition. Waltrip won Bristol the first time he and Johnson went there together in March 1981, and they kept winning until August 1984, tying Richard Petty's NASCAR record of seven consecutive victories at one track. Upon reflection, it remains a shining moment in a career that includes eighty-four Cup victories and three championships.

"Winning seven in a row, that's three and a half years. That's 3,500 laps at Bristol that you could, I guess to some degree say, were flawless," Waltrip said. "Anybody that's ever raced at Bristol knows having one race there without any problems is pretty amazing. But to have seven in a row? I look back on that, and it's got to be one of my biggest accomplishments. And at a track that—every driver will tell you—is the most difficult on the circuit."

The year 1981 was the first time NASCAR mandated the teams build smaller cars, and Johnson was on the cutting edge. Piloting a series of

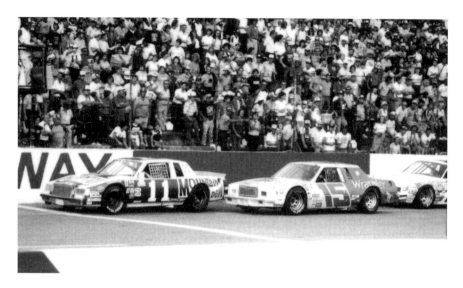

Darrell Waltrip *(11)* beat Dale Earnhardt *(15)* to win the 1982 Valleydale 500, his third of seven straight victories. *BMS Collection.*

number eleven Buicks and later Chevrolets backed by Mountain Dew, Pepsi and Budweiser, Waltrip and Johnson rarely thirsted for victory.

During that seven-race-winning stretch, DW led more than 1,500 laps, including more than half of each race on three occasions. Only once during those three and a half years did Waltrip lead less than 200 laps.

For the first five of those wins, Bristol owner Gary Baker was there to present the trophy to Waltrip. Their semiannual meetings ended in 1983 after Baker's former partner Warner Hodgdon wrestled away speedway ownership.

"Gary Baker was always funny," Waltrip said. "Gary was so excited because he's a big race nut anyway, and he thought it would be great because he could go to victory circle after the race and present trophies to all his heroes. The years he owned the track, I was about the only guy that ever won a race there. He was so upset and disappointed because he thought he would meet all his heroes and didn't get to meet any of them."

The most unique finish of Waltrip's win streak came in August 1983, shortly after Baker's departure.

After qualifying on the front row, Waltrip led three times for 207 laps during the first half of the race before Dale Earnhardt pushed his Bud Moore Ford to the front.

"Dale and I were having a pretty good go of it," Waltrip said. "There was rain in the area, and you could see the lightning off the third turn and

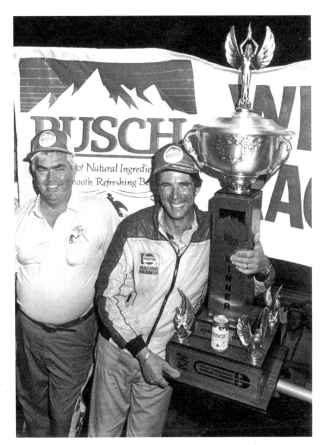

Junior Johnson *(left)* and Darrell Waltrip were the first to collect the current generation Bristol trophy with their 1983 Busch 500 victory. *BMS Collection.*

a caution came out. Everybody dove onto pit road, and Dale had beaten us out of the pits all night long. But I was able to get in and get out and beat Dale out of the pits. As soon as we came out and got up on the back straightaway, it started raining. They called it because of rain."

Waltrip and Johnson extended their winning streak to seven in April 1984, despite crashing during Saturday's practice. The team repaired their primary car for the race and spent much of the day chasing Bobby Allison. Waltrip went to the front after Allison's Buick suffered mechanical problems.

"I thought I saw Bobby's car smoking, and I told myself I was seeing things," Waltrip said after winning. "But then he went into the pits. I just said, 'Seven, here comes eleven.'"

That victory tied Petty's mark set at the old Richmond, Virginia fairgrounds and set up a much-hyped run for the record in August 1984. Waltrip's bid ended, not by a thrilling last lap pass but a rare mechanical failure.

"The eighth one was a piece of cake," Waltrip said, the disappointment still evident a quarter century later. "Some of those seven, I didn't always have the best car, but the eighth one I had the best car. And I may have had a lap on the field, and we broke a gear. We never broke a gear."

That kind of success also generates considerable pressure.

"You're trying to do something nobody else has ever done," Waltrip said. "You go there knowing you can win, because you have, but you also know this streak can't go on forever. It was disappointing, but it was somewhat of a relief because you finally got that target off your back."

While Waltrip recorded Bristol wins for four different car owners, including himself and Rick Hendrick, his mesh with Johnson was one for the ages. Waltrip said:

> *What Junior knew about Bristol and short tracks, and what I knew about Bristol and short tracks, and how I liked the car and drove it, was just the perfect combination. Junior knew about Bristol. He had a thing he did with the front sway bar and I had a thing I did with the rear springs and we did some things with the shocks.*
>
> *His engines on short tracks were phenomenal. We'd pull a much lower gear than everybody else. Everybody else would pull a high gear, because of the speed and we would pull a really, really low gear and it gave me a lot of power up off the corner. I could pass people when other guys couldn't.*

That perfect combination split up after the 1986 season when Waltrip left to drive for Hendrick and ultimately to earn two more Bristol wins, but he enjoyed a comfort zone with Bristol before and after teaming with Johnson.

"I wasn't intimidated by the track and how fast it was—it just fit," Waltrip said. "I loved the short tracks, I always have. I think it's the best racing, the most exciting racing, and if you look at my record, half the wins I have came on short tracks," Waltrip said.

Of Waltrip's eighty-four Cup series wins, twelve came at Bristol; eleven at Martinsville, Virginia; ten at North Wilkesboro, North Carolina; eight at the old Nashville Fairgrounds; and six at Richmond, Virginia—short tracks all.

Never bashful, Waltrip contends that part of his success was the mind game of convincing other drivers how much he relished the challenge of Bristol's high banks and high speeds.

> *Before we flew everywhere, I was driving to Bristol. I hadn't raced there but a few times, and they were interviewing drivers on the radio: Richard*

Petty and Cale Yarborough and Bobby Allison and Neil Bonnett. And most every driver would say, "I hate that place." "The race is too long." "Five hundred laps is ridiculous." "It's like being in a blender."

Nobody had anything nice to say. I always kind of marched to the beat of a different drum so, when I heard them all say how much they hated it, I knew what my advantage would be. I love it. It's my favorite track and I wish it was a thousand laps. That was the approach I took. So, while the other guys were moanin' and groanin,' I was getting the job done.

All the bravado in the world won't relieve an aching back or neck on a hot afternoon wrestling a nearly two-ton race car around Bristol at 120 miles per hour. And therein was another key to DW's success.

Waltrip said:

For the most part, I was younger than my competition in the '70s and '80s. I was in great shape. I ran track in high school, so endurance was kind of my specialty. I was a half miler and a miler, so I understood about saving a little something—to have a little kick at the end of the day to try to pull a win out. That's how I raced that place. I always saved a little for the end. That's how I won a lot of the races I won, because I was in better shape than most of the other guys.

It also never hurt, Waltrip said, to have great crew chiefs like Jeff Hammond, Tim Brewer, Buddy Parrott, David Ifft, Barry Dodson and Jake Elder.

"I never had a bad crew chief almost my whole career," Waltrip said. "That was part of the key to my success—people who knew how to set cars up and make cars run good. I always tried to keep one of them in my corner."

Chapter 13
TROPHY DASH

It debuted in August 1983 when Darrell Waltrip outran Dale Earnhardt and a thunderstorm. It was there for Waltrip's twelfth and final Bristol win, both victories by Alan Kulwicki, all nine victories racked up by Rusty Wallace, five by Jeff Gordon and even shared victory lane with both Terry Labonte and Dale Earnhardt, after each escaped a last lap dustup with the other.

It even had a cameo in the movie *Talladega Nights*.

It is the Bristol trophy. Standing an outrageous four feet tall and weighing fifty pounds, the trophy is a substantial reward for anyone able to conquer racing's toughest track. But woe to the arm-weary driver who tries to hold it above his head after five hundred grueling laps.

Former Bristol owner Warner Hodgdon presented the first version of the trophy to Waltrip and car owner Junior Johnson after the 1983 Busch 500. Hodgdon had taken sole control of the Bristol track that summer and hired cofounder Larry Carrier to manage the daily operations. Since Hodgdon had a flair for doing things on a grand scale, one of Carrier's first actions was to upgrade the race winner's hardware.

"When Mr. Carrier came back in 1983, his idea was to have a large trophy for the smallest, fastest track," trophy supplier Eddie Allison said. "Well, I'd seen this one at a trade show, so I got one and put it together, and it's worked out pretty good."

In addition to being a longtime race fan who attended Bristol's first race in 1961 and many of them since, Allison is a master of the understatement. The trophy remains one of the most coveted, most recognizable in motorsports, and Allison has assembled every one in his Bristol, Tennessee shop.

From its eighteen-inch-square, solid-wood base to its oversized, oxidized aluminum bowl topped with a twelve-inch winged female statue, the classically styled trophy is unlike any other.

Signature trophies help distinguish tracks, Waltrip said.

"They have the guitar in Nashville, the grandfather clock in Martinsville, and they've had the same trophy for the Coke 600 for years," Waltrip said. "You want to have something unique. The thing about Bristol's trophy is it's bigger than everybody else's. Not only was it a big deal to win the race, they gave you a big trophy for winning it."

Waltrip treasures trophies from all of his wins, but admits it's an impressive site when all of his Bristol trophies are lined up in a row.

Allison's shop has provided trophies for every Bristol owner since 1979, but current owner Bruton Smith once contemplated replacing the oversized trophy with something a bit more modern.

"After Mr. Carrier sold out to Mr. Smith, there was some debate about whether to keep that big trophy or not," Allison said. "Then Jeff Byrd called one day and said they'd decided to keep the trophy and only change it a little bit. The trophy has been there, and I think it stands on its own."

The award's classic style and cartoonish size also caught Hollywood's eye, prompting its inclusion in *Talladega Nights*, the Will Ferrell comedy centered on NASCAR racing.

Beyond Wallace's nine trophies, the late Dale Earnhardt took the big trophy home from seven of his nine Bristol wins, and Waltrip earned five. Allison has also reconditioned some trophies owned by Wallace and Waltrip.

Among active drivers, Jeff Gordon and Kurt Busch have five apiece through the track's first one hundred races, with Gordon winning four straight Food City 500s, between 1995 and 1998. Busch captured five Bristol trophies between 2002 and 2006, while younger brother Kyle took home four of the big trophies between 2007 and 2010, when he won the track's one hundredth Cup race. Denny Hamlin, who attended Bristol races as a youngster in the 1990s, said before the 2011 season began the Bristol trophy remains the one he desperately wanted to add to his collection.

"I've gotten to meet a lot of the drivers, owners and race team personnel and they're great," Allison said. "When Jeff Burton won, he came in and bought thirty-five of a smaller version for his entire team. We had them lined up and down the hallway."

Chapter 14
RACING THROUGH BANKRUPTCY

Larry Carrier opened the door of the Watson, Tipton and Jones law office on Eighth Street in Bristol, Tennessee, and stepped inside. It was late fall of 1984, and Carrier, the general manager of Bristol International Raceway, needed some expert advice on the intricacies of bankruptcy law. A series of events 2,300 miles away threatened the race track that Carrier had helped create a quarter century before, and he had to do something.

Larry didn't know A.D. Jones, the smiling young attorney who came highly recommended, but Jones knew Carrier by reputation. Seated at a conference table, Jones listened and took notes while Carrier explained the circumstances.

The Bristol track's owner, California millionaire Warner Hodgdon, was shedding business interests after an employee of one of his companies was implicated in a bid-rigging scheme. The mounting lawsuits put the Bristol speedway's future in jeopardy, Carrier told Jones. As the year wore on, Hodgdon had surrendered his interests in North Wilkesboro Speedway in North Carolina and Carrier's International Hot Rod Association drag racing group, which was based in Bristol, Tennessee. But before it was done, lawsuits against Hodgdon totaled more than $50 million, and he was preparing to file Chapter 11 bankruptcy in San Bernardino, California.

"Larry came to me when Warner Hodgdon was on the verge of bankruptcy," Jones said. "Nobody knew what was going to happen, and Larry wanted to get the track back."

As the two men talked, the intense Carrier may have never noticed the knowing smile on the attorneys' face—not for his new client's plight, but for

Jones's own lifelong fascination with stock car racing and the very track he was about to help rescue.

Some two decades before, Jones had ridden his bicycle past Gene Blackburn's Shell service station, once located exactly where the law office now stood. Blackburn was a hometown driver and mechanic who competed in two early Bristol NASCAR races. Not only did his race car command the youngster's attention, but he often loaned out the bays of his station to other drivers. It was common to see racers like Wendell Scott use the garage to pound out last week's dents or resurrect worn-out racing engines in time for another race.

Growing up a NASCAR fan in a NASCAR town, young A.D. once resorted to selling home-canned vegetables out of his mother's cupboards, figuring that, if he could raise enough money for a race ticket, his father would take him. He did pretty well until a neighbor told his mom what he was up to. While she wasn't amused, his father relented and said, "If you want to go that bad, come on, I'll take you."

Once he grew up, Jones attended college and, later, law school, but he never outgrew that boyhood love of stock car racing. As an adult, Jones returned to Bristol, joined the successful firm and began practicing law on a spot where high-octane racing fuel once flowed.

Carrier had sold his interest in the speedway after the 1977 season, weary of bad weather, short fields and not enough income from a sport that seemed stuck in neutral. But he returned in 1983 after Hodgdon took control. During Carrier's absence, TV exposure was helping fuel NASCAR's renewed momentum, and Bristol was again selling out, as fans clamored for tickets to the sensational new August night race. Carrier's plate was already full with

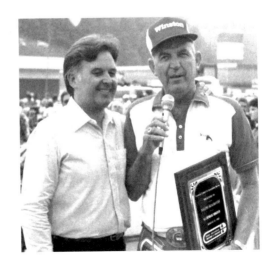

Former Bristol track owner Warner Hodgdon *(left)* presents an award to Winston's Ralph Seagraves in 1983. *David McGee.*

other business ventures, but with Bristol's fate hanging in the balance and the promise of better days, he was now intent on reacquiring it.

"Larry negotiated a deal, but there were other people involved who would have loved to have gotten their hands on Bristol Motor Speedway," Jones said. "But Jim Hunter and Bill France of NASCAR let it be known the only person who would have those race dates was Larry Carrier. If anybody else wanted it, they'd just be buying a big flea market."

It seems France had long been leery of Hodgdon, while his friendship with Carrier dated back to when his father, NASCAR founder Bill France Sr., ran the organization.

Carrier's plans hit a temporary snag when he couldn't finalize a deal with the bank holding the first mortgage on the speedway.

"A problem arose over the fees for the attorney for the bank," Jones said. "And Larry was adamant he wasn't going to pay their attorney's fees"—adamant to the point that Carrier and the banker almost came to blows while sitting around the conference table in Jones's office!

"The banker said they would go ahead and file the lawsuit and put the track into bankruptcy," Jones recalled. "Larry looked at him and said, 'You're nothing but a phony.' I thought they were going to fight right there."

With the bankruptcy moving forward, Carrier's prior agreement with NASCAR became a deciding factor for the California court.

"We had to get affidavits from NASCAR into that bankruptcy proceeding, that there was no guarantee the race dates would go with the sale of the track," Jones said. "NASCAR was committed to Larry Carrier, and that was just on a handshake."

The clincher was Carrier's business relationship with Hodgdon. In addition to working for Hodgdon as the track's general manager, Carrier was also a business partner, to whom Hodgdon owed money.

When the case was heard in February 1985, the bankruptcy court declared Carrier a debtor in possession and appointed him to run the track.

"We were able to buy the stock back for Bristol International Raceway for a pittance," Jones said. "By buying stock, Larry was able to pay off First Tennessee Bank for a lesser amount than he'd offered previously. He paid off some unsecured creditors and went back in business."

As part of Hodgdon's 1983 takeover of the Bristol track from former partner Gary Baker, he also controlled the hallowed Nashville Fairgrounds Speedway, where NASCAR's stars raced since 1958. Sadly, the popular Nashville track wasn't so lucky. After the bankruptcy, NASCAR canceled two Winston Cup races originally scheduled there in May and July 1985, and the old fairgrounds fell off the Cup schedule forever.

Chapter 15
ONE TOUGH CUSTOMER

When Dale Earnhardt appeared in a series of 1980s Wrangler print and broadcast commercials, branding him "one tough customer," everyone from the garage area to the grandstands knew it was an ideal blend of marketing and reality. That larger-than-life persona, which appealed to NASCAR's blue collar fan base like no other, swelled to new heights after Earnhardt's performance in the 1985 Valleydale 500.

"I went 400 laps without power steering and, if the car hadn't been handling, I couldn't have done it," Earnhardt admitted after the race. "I've never driven a car which had lost the power steering and I hope I never have to again. I had to pull on the steering wheel so much my right arm felt like it went to sleep for the last 100 laps."

The race featured a then Bristol record fifteen cautions for eighty-nine laps, which banished many of the day's other contenders behind pit wall. Only Ricky Rudd was able to remain on the lead lap with Earnhardt, but he finished 1.1 seconds behind. Third-place Terry Labonte and fourth-place Buddy Baker were two laps down, and fifth-place Rusty Wallace finished three laps down.

The number-three car's power steering failed just after Earnhardt took the race lead for the first time. After briefly giving up the front spot to pit under caution, Dale then had to battle with Wallace, Sterling Marlin, Baker and Rudd throughout the afternoon. In all, Earnhardt led seven times for 218 laps, which meant he passed someone for the lead six times by man-handling the steering wheel. His last pass was of Rudd's Ford with 18 laps remaining.

Dale Earnhardt won Bristol in 1985 despite power steering failure. *Earl Neikirk*/Bristol Herald Courier.

"I like power steering," Earnhardt joked. "It's just a problem when you lose it. It's like holding the car up with your right arm when you go through the corners. It was the longest 400 laps I've ever run."

He radioed the crew after 150 laps of the race—50 laps after the failure—and asked them to find a relief driver.

"If the car hadn't been handling good, I couldn't have finished the race," Earnhardt said. He asked car owner Richard Childress to get Darrell Waltrip, who fell out of competition early, to stand by. Earnhardt credited the caution periods with giving him enough of a break to not need relief.

A few years later, Earnhardt dealt with some entirely different challenges.

A horrific crash at Talladega left him nursing a broken collarbone and fractured sternum, but Earnhardt turned in a gritty performance by winning the pole at the road course in Watkins Glen, New York. He led the most laps that day and posted a remarkable sixth-place finish. The following night, Earnhardt walked gingerly into the Bristol speedway press box to talk with the media about the upcoming Goody's 500.

"If you can ask me a question I haven't answered lately, you can ride with me around the race track," the seven-time champion offered. After a

couple of media members took unsuccessful stabs, track PR man Wayne Estes asked, "If you were a tree, what kind of tree would you be?"

Without hesitation, the obviously uncomfortable Earnhardt said, "A mighty oak." But the pain in his eyes left no doubt that Bristol wouldn't be easy. Earnhardt gave way to a relief driver when the tour reached Indianapolis but wouldn't allow himself that luxury the next week at Bristol. While he didn't win that August night race, his performance was amazing.

After aggravating those injuries during practice and qualifying a paltry twenty-fourth, he raced into the top twelve before a lap 212 collision with Lake Speed created both overheating and handling problems. Despite having Mike Wallace standing by in the pit area, Earnhardt carried a wounded car to a gritty twenty-fourth place finish.

Chapter 16
PRIME TIME

Larry Carrier scanned the skies for any hint of clearing, scowled at the persistent showers making his glasses and race track wet and shook his head in disgust. Afternoon was quickly fading into evening, and the rain was threatening to undo months of work and planning. It was August 1985, Carrier's first pivotal season back in the ownership saddle of Bristol International Raceway after the Warner Hodgdon bankruptcy, and the weather was tying his stomach into knots.

Already that season, Bristol's spring race was rained out and had to be run the following Sunday. For reasons beyond the financially obvious, Carrier desperately needed the showers to stop and the Busch 500 to begin. For that night, in addition to the thirty-five thousand soggy fans in Bristol's grandstands, the audience would include millions ready to watch NASCAR's first live, prime time national telecast.

The cameras of ESPN (Entertainment and Sports Programming Network) were poised to bring some slam-bang Saturday night short-track action into America's living rooms—if only the cursed rain would cease. It did and the rest, to borrow the cliché, is history.

In the 1980s, each track negotiated its own TV broadcast contracts, and Carrier had carefully cultivated his relationship with ESPN. Much like he brought R.J. Reynolds's Winston brand to drag racing through his NASCAR affiliations, Carrier worked with the sports network through both the speedway and his International Hot Rod Association drag racing group.

Carrier's pitch to ESPN senior programs acquisitions specialist Rich Caulfield was simple: televising Bristol's NASCAR night race live in prime

Dale Earnhardt *(3)* held off Tim Richmond *(27)* to win the 1985 night race, NASCAR's first prime time TV broadcast. *BMS collection.*

time and his IHRA drag racing events was a package deal. He basically gave away the first rights to the night race, knowing if fans saw it, they'd want to come buy a ticket. While lighting Bristol would be a challenge, the half-mile track's growing reputation made ESPN's decision easy.

"When we started our Winston Cup Grand National coverage in 1982, we didn't expect to draw the kind of ratings we had from year to year," Caulfield said in story appearing in the 1985 Busch 500 race program. Once a racing novice, Caulfield quickly recognized the sport offered unique storylines and ardent fan support.

"Race fans want to see as much of an event as possible. Our objective is to give the fans exactly that," Caulfield said. And they ate up Bristol. Besides the Cup races, ESPN also televised both of Bristol's Busch Series races live that season—a network first. Using just seven cameras and supplemental lighting to illuminate the high-banked half-mile, viewers had plenty to watch.

After running five laps under caution for lingering raindrops, the thirty-one-car field staged what can easily be described as a Bristol classic. Eight different drivers swapped the lead eighteen times, as fastest qualifier Dale Earnhardt, Darrell Waltrip, Neil Bonnett and Bill Elliott mixed it up. Earnhardt took charge just past the race's midway point, leading from lap

261 until 446, when things really got interesting. Tim Richmond took the lead by not pitting under caution, as Earnhardt and other lead lap cars made the night's final pit stops.

Richmond was able to hold off repeated challenges by Earnhardt's Chevrolet until the "Intimidator" bumped him aside in turn three, with eighteen laps remaining. After winning by just three car lengths, Earnhardt described his pass of Richmond as "close, hard racing." But the runner-up told the TV audience that the aggressive move was "just one of Earnhardt's normal tactics."

The night included fourteen caution flags, the expected sheet metal carnage and another storyline for ESPN to follow. Waltrip and Elliott, the two drivers locked in a battle for that season's championship, finished one spot apart but embroiled in a scoring controversy. In short, it was pure television magic delivered live into millions of American households.

"Larry Carrier doesn't get enough credit for what he did with TV," former speedway general manager Denny Darnell said. "Putting the night race live on prime time television was a landmark moment."

Chapter 17
"HARDEST HIT EVER"

Bristol International Raceway's once raucous crowd suddenly fell silent, holding their collective breath and fearing the worst while hoping they hadn't witnessed the unthinkable. Moments before, some two dozen colorful racers buzzed around the track, but at that moment, only one mattered, and its pieces lay scattered.

Seconds seemed like hours as fans focused on rescuers frantically peeling away tattered chunks of a metal onion. Somewhere among the severed sheet metal, twisted roll bars and fractured frame rails that once comprised a race car was Michael Waltrip. Unbelievably, when the last panel was pulled back, a dazed Waltrip looked at rescue workers through groggy blue eyes, put his feet down on asphalt where floorboard should have been and stood up. Emerging from that multicolored disaster after three torturous minutes, Waltrip was greeted by the sobs of his brother, Darrell, amazed looks from emergency workers and a standing ovation from the disbelieving multitudes.

On April 7, 1990, on lap 171 of the Budweiser 250 Busch Series race, Bristol fans witnessed one of the most violent single-car crashes in racing history—and the driver literally walked away. The crash was pictured on the cover of *Stock Car Racing* magazine's July 1990 issue beneath a headline proclaiming it the "Hardest Hit Ever." More than two decades later, few can compare.

In the chaotic moments after he was taken to the infield care center, a team public relations representative distributed a telling quote to the news media: "My head is sore," Waltrip said. "My neck is sore. I'm a little confused, but that's nothing new for me."

Track president Larry Carrier often said the greatest moment of his life was seeing Waltrip emerge alive from the wreckage.

Lifelong Bristol race fan Fred Hayter, who's seen every Bristol Cup race ever held, recalled the moment vividly. "I was sitting over on that side, and I'd been watching Michael," Hayter said. "Stuff flew up on me when he hit and then it got so quiet in there. I never will forget that."

Veteran driver Dick Trickle characterized Waltrip's Houdini-like escape as "the most amazing thing" he'd ever seen. And fellow driver Kenny Wallace was forced to take evasive measures seconds after the impact to avoid tragedy. "I turned that car as hard left as I could to keep from running over him," Wallace said of the seemingly lifeless car sitting in the middle of the track.

Michael's older brother, Darrell, was nearly overcome with emotion.

"I was standing there watching it, and I just froze," the senior Waltrip said. "I couldn't move. I didn't see any way he could survive that."

Michael had been racing side by side with Kyle Petty before spinning and restarting at the rear of the thirty-car field. Charging through the pack, Waltrip attempted to pass Robert Pressley's Oldsmobile on the high side in turn one. Pressley moved up in turn two, and the cars touched, causing Waltrip's Pontiac to slide up the track.

Once Waltrip's tires lost adhesion in the little-used top groove, he was along for the ride, blasting into the steel crossover gate above the second turn. As the gate buckled, it exposed the end of the backstretch concrete wall that Waltrip then struck at one hundred miles per hour.

Waltrip's car exploded on impact, disintegrating around him. Red, yellow and blue body panels broke apart at their welds; the complete right-side bars of the roll cage embedded between the concrete wall and gate; the floor pan was torn away beneath Waltrip's feet; and his racing bucket seat was held in place by a single bolt because the others were sheared off. Track workers loaded a rollback wrecker with the remaining scraps.

After being treated in the infield care center for minor cuts, bruises and a concussion, Waltrip was flown to the nearby Bristol Memorial Hospital, where he stayed overnight for tests and observation. After doctors released him the next morning, he returned to run the Cup race and to answer questions about the crash.

"I remember hitting," a composed Waltrip said the morning after. "Then I remember I couldn't breathe. I must have passed out because I didn't get knocked out, because I didn't hit my head. Next thing I remember was coming to and seeing a bunch of people around."

The car hit at a slight angle, which ripped the engine out of the frame rails and away from the driver.

Waltrip said:

> *If I would have hit head-on, the motor would have ended up in my lap and probably hurt me pretty bad. The cars are just extremely safe, NASCAR does a good job getting the medical crews to you and—no matter what you do—you've got the good Lord looking over you. And I believe He performed a miracle in front of 35,000 people!*

Chapter 18
GROWING TOGETHER

Steve Smith could scarcely believe his eyes. A race car sponsored by his family's grocery stores was leading the 1991 Bud 500 at Bristol International Raceway. Not just leading but pulling away. Driver Jimmy Spencer was dominating the frenzied action while displaying the Food City name in bold yellow letters across the rear fenders and hood of Travis Carter's red Chevrolet Lumina. Smith and a group from his company watched in amazement as "their" car for the night appeared bound for glory.

"He was lapping people left and right, and a bunch of us were sitting up in the stands just pinching ourselves," Smith recalled. "But we were trying to figure out how to get to victory lane. We didn't know how to get there. We were thinking if we win this, how will we get down there in time for the celebration?"

Smith made no trip to victory lane that night; their dreams were thwarted when a mechanical glitch slowed Spencer after leading almost half the race. But that moment in the spotlight helped sow the seeds of Food City's extensive sponsorship of Bristol races, other drivers at Bristol and a four-year relationship with the late Dale Earnhardt. And, yes, Smith has since made plenty of visits to victory lane.

Food City succeeded another local company—Bristol, Virginia-based Valleydale meat packers—as sponsors of Bristol's spring race after being contacted by Ben Becraft, a representative of R.J. Reynolds Tobacco.

"Ben had a promotion he wanted to run by us," Smith said. "In exchange for us helping them with some sales, they thought they could deliver the Bristol Cup race since Valleydale wasn't coming back."

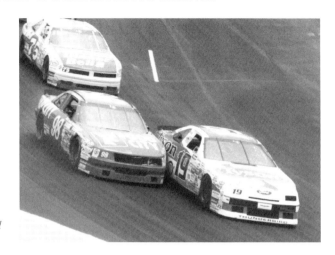

Jimmy Spencer *(98)* welcomed Food City into racing by leading at Bristol in 1991. *David McGee.*

Excited but uncertain his father, Jack, then the grocery chain's president and CEO, would go along, Steve made his best sales pitch.

"I outlined the program to him, fully expecting he may throw me out the door," the younger Smith said. Instead his father agreed, recognizing the one-year deal as a "hell of an opportunity" for the family-owned company based in nearby Abingdon, Virginia.

Two decades later, Food City's support of the Food City 500 is the second longest continuous sponsorship in the Cup series. Their concurrent sponsorship of Bristol's Food City 250 each August, which also began in 1992, is the second longest continuous sponsorship in the Nationwide—formerly Busch—series.

Much like the speedway's founders built the track at precisely the right time to capitalize on NASCAR's growth, Food City's entry coincided with a time when consumer products like laundry detergents, snack foods, coffee and pain relievers recognized racing as a viable way to promote their brands.

"It certainly worked well for us," Smith said. "We really didn't know a lot about sports marketing at the time, but we knew about being involved in the community. We had just spread out to Knoxville, Tennessee, at the time, and I think we had about sixty-two or sixty-three stores. We thought the race made a lot of sense to get our name out, not just in the Tri-Cities but the Knoxville region and eastern Kentucky."

Food City learned about racing's impact by hosting an autograph session with just two racing celebrities.

"It was in the Kingsport store with Junior Johnson and Terry Labonte, and we had a great crowd," Smith said. "The next year, we had an opportunity

Food City's Jack Smith *(left)* and BMS's Jeff Byrd *(right)* help Jeff Gordon celebrate his 1997 Food City 500 win. *David McGee.*

with Pepsi to bring Richard Petty in before he retired. It was a huge hit. We had it in the same store, and we had hundreds, if not thousands, of people in that store and were concerned it might get out of control."

Any worries the city's fire marshal would close them down subsided, however, when he was spotted in the autograph line.

Customer response to those events and that first Food City 500 soon opened the door to a new Bristol racing tradition: Food City Family Race Night. The formula brought together race drivers, fans, free products, live music and activities for all ages.

"We knew it was successful when you have a driver at a store," Smith said. "I don't think we envisioned we could have forty or fifty drivers on State Street or some of these areas. And back then, the drivers were more than willing to get out and sign autographs and promote their products."

Each August, race fans by the thousands congregate on the state line of Tennessee and Virginia for the sport's biggest prerace party. Working with the two Bristol city governments and merchants, Food City turns downtown Bristol into a pedestrian mall for race fans.

"I don't think there's a single popular name driver over the years that, at one time or another, didn't show up at Food City Family Race Night," Smith said. "From Jeff Gordon and Dale Earnhardt, to the Pettys, Junior Johnson, Bobby Allison, Ned Jarrett, and David Pearson—they've all been there."

The company donates proceeds from its events to charitable and community organizations.

In 1995, Food City got even more involved by sponsoring Dale Earnhardt despite a somewhat awkward beginning.

Jack Smith and members of his staff had worked out the basic agreement and wanted Steve, who missed the initial meeting, to go to North Carolina and finalize the contract. They didn't tell him a surprise was waiting.

"Dale walked in, and it was like the president of the United States," Steve Smith said. "We all stood up, and they don't call him 'the Intimidator' for nothing."

Earnhardt walked straight over to Smith, looked at him with his steely gunfighter's gaze and said, "You must be Steve. I've heard a lot about you."

"Thanks Dale, I've heard a lot about you too," Smith replied as Earnhardt pounced. "But you've never rooted for me have you?"

Smith panicked, scrambling to find the right words.

"No, no—to be honest, I haven't," Smith stammered.

With that devilish twinkle in his eye, Earnhardt continued. "That's OK. Sit down and tell me who you root for."

Smith struggled to spit out "Darrell Waltrip."

"Well we've got more work to do here than I thought," Earnhardt replied.

"Evidently they told some stories on me and explained to Mr. Earnhardt that I wasn't a fan of his," Smith related. "I'm not too often at a loss for words, but there wasn't much coming out that day."

His mischief complete, Earnhardt and car owner Richard Childress completed the contract, and the champion driver helped decide on the size and placement of their logo on the car. When Food City renewed for two additional years in 1997, Earnhardt secured the deal with a bonus: two seasons on Dale Earnhardt Jr.'s Busch Series Chevrolet at no extra charge. That combination captured seven series wins and the 1998 championship

"I gained a lot of respect for Dale as a business person," Smith said. "He was a heck of a race car driver, but he was a heck of a business person too. He was business savvy, and his wife was too."

Food City remains in the sport because racing still resonates with customers and employees.

"It's all about selling boxes and cans," Smith said. "At the end of the day, we still look for ways to attract customers and sell more products. We probably couldn't make a business case on a profit and loss statement, but we've been growing ever since we began sponsoring the race; so it feels like a good thing and the right thing to do."

In announcing its three-year contract renewal in early 2011, Food City changed the name of its race for 2011 to the Jeff Byrd 500 presented by Food City as a tribute to the speedway's late president who died in October 2010.

Chapter 19
CEMENTING BRISTOL'S FUTURE

Bristol's biggest winner appeared distraught over the speedway's new surface, and he wasn't alone. In August 1992, just a week before they were to race there, Darrell Waltrip and about twenty-five Winston Cup teams came to Bristol to test a radically different concrete track. Nearly all of them hated it.

"I don't like it. It's rough. It's worse than it's ever been," Waltrip surmised at the end of the daylong test session. "The straightaways are smooth, but the corners are washboardy. There are a lot of ripples that make the car chatter. It gives you a real insecure feeling." Asked if he thought the surface would improve, Waltrip replied, "How can it? It's concrete."

Installed at a cost of about $1 million, the surface was speedway owner Larry Carrier's latest attempt to resolve years of problems. Carrier had tried everything—repaving, sealing and resealing asphalt—all in an effort to give drivers a safe, predictable surface to race on. And every time, it seemed, the surface failed. Whether races were affected by tires cut by shards of asphalt sealer, rough spots or the surface coming apart, the biggest story from far too many Bristol races centered on the track surface. The asphalt couldn't handle the G-force loads imposed by a pack of nearly two-ton stock cars racing at high speeds on the track's steep banking.

Carrier had nothing but frustration to show for the fortune he'd invested, and he had nearly reached his wits' end when he stopped one day at a retail warehouse construction site. As the former home builder watched workers pouring a massive concrete floor, he wondered whether they could pour that at an angle on his race track. After meeting with concrete contractor Joe

Bristol's original concrete surface was finished by hand in the summer of 1992. *BMS collection.*

Loven in the spring of 1992, the two men formulated a plan to cover the asphalt with a ribbon of concrete. But on that partly cloudy Friday afternoon in August 1992, the Bristol pit area was filled with doubters unimpressed with the finished product.

"I don't know what we're going to do," a frustrated Bill Elliott said. "I don't know how we can race on it."

Alan Kulwicki, fresh off two straight Bristol victories where he'd complained loudly about the old asphalt, again minced no words.

"Obviously they've tried to make it better," Kulwicki said. "But the bottom line is the condition of the track is not good. It's one of the roughest places I've been on. Getting rubber down might help the adhesion but not the roughness. There are big dips out there that you can't fill with rubber."

Despite being among the fastest during the test session, Dale Jarrett was also concerned.

"You're vibrating so much in the corners, it's difficult to see the car in front of you—to judge the distance is difficult," Jarrett admitted. "We're all going to have to make appointments to see our dentists if you have fillings, because after the race they're not going to be there anymore."

Dale Earnhardt offered a less dire prediction, saying, "It's going to be interesting to see what happens."

Once completed, workers removed the dust of the concrete surface so teams could race. *Bill McKee*/Bristol Herald Courier.

A handful of drivers, including Sterling Marlin, Morgan Shepherd and Geoff Bodine even expressed optimism. "Sure it's a little rough," Marlin said. "But it's not unbearable. It's sure not like '88 when it was like a launching ramp off of turn two. It's sure not that bad."

After years of criticism, Carrier took it all in stride. "I expected them to say it was rough in places," Carrier said. "I'd be surprised if they didn't. But I really feel like it's in good shape. It's like NASCAR said, they'll just have to get used to it and get their cars set up right. I think it's going to be fine."

The race—Goodyear's first time bringing radial tires to Bristol—produced no more cautions than that spring's Food City 500, and the average race speed was actually faster. There were fourteen lead changes among eight drivers, compared to eleven swaps among seven drivers in the spring.

Waltrip, among the loudest detractors, was the first to tame the concrete surface, leading four times for 247 of 500 laps, including the final 133. He even joked in victory lane that he hadn't noticed the difference. "I've been here the last 17-18 years," Waltrip said. "I've raced on this track in every condition you could think of. I feel like I've dealt with this place in every form or fashion. The track will be alright."

Earnhardt finished second by 9.2 seconds but never led a lap. Ken Schrader, Kyle Petty and Kulwicki rounded out the top five finishers. Series points leader Bill Elliott posted a solid sixth-place finish and expanded his margin over Davey Allison, who crashed while running third. It was Allison's first time back at a race track after younger brother Clifford died two weeks before from injuries sustained in a practice crash at Michigan.

Looking back, Waltrip recalls how that prerace test helped him conquer the concrete.

"I remember the concrete. It was so rough that it would chatter your teeth," Waltrip recalled. "You'd come off the second turn, and you couldn't even see the end of the back straightaway because your car was vibrating so badly. We had a lot of success up there and, when they concreted it, everybody thought we'd lose our magic."

Instead, Waltrip suggested an unlikely change to crew chief Jeff Hammond on test day.

"I told Hammond sometimes at Nashville I would reverse my rear springs—put the soft one in the right rear and the stiff one in the left. That gives the car a lot more bite up off the corner and, as rough as this track is, maybe we ought to try it," Waltrip said.

Hammond resisted, but Waltrip persisted, finally convincing him to try it since nothing else seemed to work.

Waltrip continued:

> We reversed them, I went back out and that thing came alive. It would come up off those rough corners and it tied that car to the track. That's what made us so good that night. That car would hook the bottom, come up off the turn straight when everybody else was crossed up sideways, about to spin out. We put fresh tires on it with about one hundred laps to go. I sucked it up and we just checked out on Dale and Terry and the rest and won by a half a lap. That car was just bad fast. We'd have never known that if we hadn't had that open test.

Chapter 20

A CHAMPION LOST

Thirty-five NASCAR drivers huddled together near the start-finish line of Bristol International Raceway, instead of customary prerace spots beside their cars. Bowing their heads simultaneously, the emotional prerace invocation gave all a rare moment alone with their own thoughts.

"God we are so excited when our racers come to town," the Reverend Mike Rife prayed. "But God, there are people who are hurting. God we pray for safety. We pray for enjoyment and an entertaining race but, oh God, please keep these men safe for their families."

After Rife said, "Amen," and each driver looked up, there was no cheer. For twenty-five seconds before the "Star-Spangled Banner" began, all sixty-seven thousand assembled in the grandstands and hundreds more in the pits stood silently.

"O! Say can you see by the dawn's early light."

As those familiar words filled the stadium, thirty-five pairs of eyes surveyed the race fans surrounding them. Many wiped away tears looking at homemade signs, reading "We miss you No. 7" and "We miss you Alan" that were scattered among the flags and banners for No. 3 or No. 2.

"O'er the ramparts we watched, were so gallantly streaming?"

Bristol races are semiannual celebrations, but the somber mood on April 4, 1993, matched the cool temperatures and overcast skies. It was race day at Bristol, unlike any other before or since, and there was little appetite for celebrating.

"Gave proof through the night that our flag was still there."

Along pit road, crewmembers from those race teams stood silent vigil over thirty-five race cars, each with a black No. 7 decal carefully affixed. In a sport filled with machismo, the decals provided a simple, silent tribute.

"O'er the land of the free and the home of the brave?"

As the final notes faded, there was no boisterous cheer from the grandstands, just a polite reaction to the anthem singer. Everyone, it seemed, was thinking about who should have been the thirty-sixth driver to compete that afternoon.

Alan Kulwicki was the 1992 Winston Cup champion, snatching the title away from favored Bill Elliott and Davey Allison in the previous season's final event. His ten-point margin is among the slimmest in NASCAR history. Dubbing his Fords "Underbirds" rather than Thunderbirds, Kulwicki's small but loyal band operated with less funding, fewer employees and less technological resources than its rivals. What they had was Kulwicki, a college-educated engineer with an uncanny eye for detail, a bulldog's determination and a belief that nothing was impossible for those who labored tirelessly.

Kulwicki's crew members took their cues from the boss, and together, they broke the stranglehold of larger, better-financed teams winning the NASCAR championship. The early kick in that title-stealing run came at

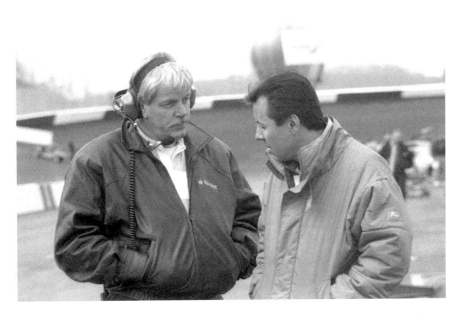

Alan Kulwicki *(right)* talks with Robert Yates before the 1992 Food City 500. *David McGee.*

Bristol, as Kulwicki held off Dale Jarrett—in a car prepared by one of those better-funded teams—to win the 1992 Food City 500. Alan's victory also stopped Bill Elliott from winning for the fifth consecutive time that year and running away with the championship for car owner Junior Johnson.

It also marked the second straight time Kulwicki carried the orange and white Hooters Restaurants colors into Bristol's victory lane. Bristol was the only track where the Wisconsin native recorded multiple wins, and his first Bristol victory in August 1991 provided a pivotal boost toward signing a desperately needed three-year sponsorship agreement with the popular Hooters chain.

But even in the glow of that first victory, Kulwicki served up some harsh words about Bristol.

"I like this track," Kulwicki said after his 1991 win. "The people here are great but this business of sealing it before every race—all this slipping and sliding—it's not very professional. We shouldn't have to race on this kind of surface. It's not up to par. It's not safe"

In the early 1990s, Bristol was bursting at the seams. New grandstand seats were sold as soon as they could be built, and keeping up had become a challenge because the track sold out every race. The greater problem had been the track itself. The combination of heavy cars, high speeds and steep banking in the corners created an asphalt engineering nightmare that no measure of repaving or sealing could seemingly solve.

The race winner closed his 1991 interview with a remark that really got under track owner Larry Carrier's skin. "All it takes is a little money and a little time," Kulwicki said.

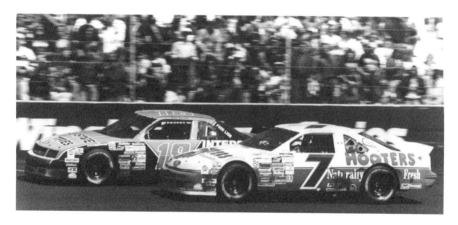

Alan Kulwicki *(7)* races with Dale Jarrett *(18)* during the 1992 Food City 500, won by Kulwicki. *BMS collection.*

While Carrier resented the criticism from someone who just collected $61,400, his response was a $1 million resurfacing project that provided all new asphalt in time for the 1992 Food City 500. Kulwicki promptly reset the track qualifying record and won the race. "I wasn't the first guy who complained about it, but maybe I was the first winner who complained about it," Kulwicki said after qualifying for the race's pole position. After earning his second straight Bristol win, Kulwicki admitted he liked Bristol "better and better."

Still dissatisfied, Carrier spent another $1 million to replace the new asphalt with concrete prior to the August 1992 Bud 500. Kulwicki was among those unhappy with that decision, calling Bristol one of the roughest places he'd ever raced. After a fifth-place finish in that first race on concrete, Kulwicki and crew chief Paul Andrews returned to Bristol in March 1993. They brought two nearly identical cars to test suspension parts and setups in hopes of returning to victory lane in the upcoming Food City 500.

Tragically, Kulwicki never had a chance to defend that crown. At 9:28 p.m. on Thursday April 1, 1993, Kulwicki's twin engine Fairchild Merlin 300 airplane slammed into a field north of Island Road near Interstate 81, about seven miles northeast of the speedway. Eyewitnesses in the Tri-Cities Regional Airport control tower, at the Sullivan County Tennessee Sheriff's Office and shocked nearby residents reported the plane's nose dropped suddenly, and it came straight down six miles east of the airport runway.

Kulwicki's plane had departed McGhee-Tyson Airport at 8:45 p.m., after the champion made a personal appearance for his sponsor at a Hooters Restaurant in nearby Knoxville, Tennessee. During the ninety-mile flight, Kulwicki used his cell phone to call friends who were to pick him up at the Appalachian Flying Service hangar and drive him to dinner in nearby Johnson City, Tennessee.

It was a cold rainy night with a hint of snow in the air as sheriff's deputies, volunteer firefighters, medical responders and concerned neighbors clambered up the muddy incline to the crash site, desperately hoping someone had survived. While unsure who was onboard, all were aware the drivers for the weekend's NASCAR race would be arriving, because practice and qualifying were to begin the next morning.

Flames and smoke billowed from the wreckage, partially obscuring the N500AK registration numbers that identified the plane as one owned by the restaurant chain and used by its championship-winning driver. Once the blaze was extinguished, investigators began the grim task of recovering four bodies—three burned in the fire and a fourth thrown clear, still clutching a cell phone.

Alan Kulwicki was among four killed when his airplane crashed a few miles from the speedway on April 1, 1993. *David McGee.*

Word of the tragedy spread rapidly through the racing community. Paul Andrews, team engine builder Danny Glad, public relations representative Tom Roberts and others assembled at the airport's private aviation hangar. It was after 3:00 a.m. when they received official confirmation: the crash had claimed Kulwicki; Mark Brooks of Atlanta, Georgia; sports marketing manager of Hooters America, Inc., and son of company chairman Robert Brooks; Dan Duncan of Taylor, South Carolina, Hooters director of sports management; and Charlie Campbell of Peachtree City, Georgia, Hooters' corporate pilot.

The impact was horrific, investigators said, with debris contained within a tight sixty-two-foot radius. The National Transportation Safety Board later determined the probable causes of the crash were icing conditions and the pilot's failure to properly manage the plane's anti-icing controls.

The finality of the previous evening hit the assembled racing community foursquare on a bitterly cold Friday morning. Peter Jellen, who had driven the team's transporter to Bristol the night before only to learn the shocking

news, had that truck sitting near the track's start-finish line. With a mixture of rain and snow falling, Jellen began a mournfully slow lap around the speedway. Crew members from all of the Cup and Busch Series teams stopped working and stood quietly along both pit roads as Jellen circled the track and then turned at the turn three gate toward Charlotte, North Carolina, and uncertainty.

While many drivers would have preferred the day off on Sunday, all agreed Alan would want them to race—and race they did. In an entertaining afternoon, Jeff Gordon, Kenny Wallace and Bobby Labonte all made Bristol Cup series debuts; Dale Jarrett threw his helmet at Bobby Hillin's car after an early crash; and Rusty Wallace outran Dale Earnhardt for the win. Wallace, a longtime friend of Kulwicki, then did something magical. To the cheers of the crowd, he spun his black Ford around and circled the track clockwise for a "Polish victory lap," just as Kulwicki had done to celebrate his first win in Phoenix in 1988.

"To win this race is a big deal, but it is a bigger deal to win it for my buddy Alan," an emotional Wallace said. "I dedicate this race to him and his family. I don't want my good run to overshadow what happened to him."

Chapter 21

THE WATER BOTTLE

The 1995 Goody's 500 is best remembered for its last-lap drama starring eventual winner Terry Labonte and Dale Earnhardt, who knocked Labonte's Chevrolet into the outside wall at the start-finish line. But it was an earlier Earnhardt tap that sent Rusty Wallace's car careening into the wall, effectively spoiling his night.

The showdown was set up during qualifying, when Wallace drove "Midnight," his favorite Ford Thunderbird in Roger Penske's stable, into the fifth starting position. Qualifying two spots slower and starting right behind him would be Earnhardt's familiar black and silver Richard Childress Chevrolet.

Prerace patience was in short supply Saturday night after rain delayed the start by more than ninety minutes. While fans and crewmen entertained themselves by performing the wave around the Bristol oval, drivers waited and worried whether the race would go the distance, be shortened due to weather or begin at all.

A light drizzle fell as the green and yellow flags were unfurled just past 9:00 p.m., but the action heated up shortly after the caution flag was withdrawn. Wallace moved into fourth place by lap thirty-two, with Earnhardt's Chevrolet in tow. As Wallace and Earnhardt exited turn four, Dale closed in and bumped the rear of Rusty's car, shooting him sideways toward the outside wall and opening a gap for Earnhardt to rush through. During the ensuing caution, NASCAR directed Earnhardt to the rear of the field for rough driving, drawing a mixture of reactions from the wildly partisan Bristol crowd.

"Before the race," Wallace said, "Earnhardt told me he was tired of Jeff Gordon winning all the time, and he was gonna spin him out, and then me and him would go to the front. And the first thing he does is hit me."

Wallace returned to the track after repairs were completed, but a later run-in with another driver relegated him to a twenty-first place finish. In the meantime, Earnhardt was marching through the field before the last-lap showdown with Labonte. But the fireworks didn't end with the checkered flag.

Back on pit road, Earnhardt was standing beside his car doing a radio interview. "He bobbled up off the corner there," Earnhardt told the audience about Wallace. "And I bumped him and spun him. It was all just good, close racing."

What Earnhardt didn't know was that Wallace was approaching. Rusty hurled his nearly full water bottle, bouncing it off Earnhardt's car and face while yelling, "I ain't forgetting this and I ain't forgetting Talladega."

Afterward, the still-upset Wallace explained, "I walked up to him and I wanted to talk to him but I couldn't get his attention. He had all these people standing around, so I took the water bottle and slung it off his head. Then I got his attention."

Wallace's early turn four crash that night was thankfully nothing like a much scarier incident in about the same spot a few years earlier.

A Friday afternoon practice session was just beginning for the 1988 Busch 500 when Wallace, the Winston Cup points leader, sailed his Pontiac into turn four and the right front tire exploded. It instantly shot Wallace's car head-on into Bristol's unforgiving concrete wall. With the tire reduced to shreds, the car's now exposed steel wheel dug deeply into the asphalt and launched the car into a violent series of barrel rolls. Only the concrete wall separating race track from pit road proved immovable enough to halt Wallace's tumbling, as the badly mangled car landed with a final, sickening thud.

Jerry Punch, an emergency room physician and ESPN television reporter, sprinted to the steaming hulk of metal. Wallace was unconscious and had momentarily stopped breathing. After Punch revived him, rescue workers got him out of the car, onto a backboard and transported him to the nearby Bristol Memorial Hospital in Bristol, Tennessee. Amazingly, his date with Bristol's unforgiving walls produced little more than a stiff neck.

The real victim of Wallace's bucking bronco ride was his chance to win that season's championship. The tour's arrival at Wallace's favorite track was expected to generate gains over points rival Bill Elliott instead of a title-crippling setback.

Confident their driver was OK, crew chief Barry Dodson and the rest of Wallace's team hurriedly went to work preparing their backup car. Fresh

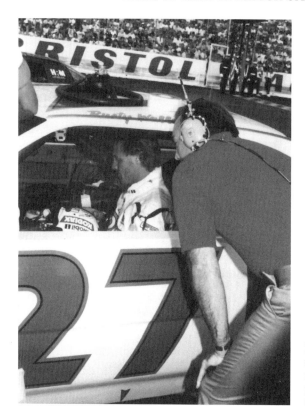

ESPN's Jerry Punch *(right)* speaks with Rusty Wallace the day after a serious 1988 practice crash at Bristol. *BMS Collection.*

from the hospital on Saturday, Wallace recorded the fastest lap during second-round qualifying and earned a seventeenth-place starting spot for that night's race. After 211 laps, however, bravado surrendered to reality when Wallace gave way to Larry Pearson, the previous night's Busch Series race winner.

"In all my years of racing, this is the first time I've had to get out of my car," a disappointed Wallace told the news media. "My neck just gave out. Physically I feel fine, but I could tell 25 laps into the race I wasn't going to make it. The best thing to do was just grin and bear it, and get out of the car and let Larry take over."

Pearson steered the unfamiliar Pontiac to a ninth-place finish, seven laps behind race winner Dale Earnhardt. But that night represented a fateful swing in points. Elliott finished a strong second, catapulting him from twenty-one points behind to sixteen ahead and setting up his run to the 1988 championship. Wallace, whose crash occurred at the height of a war between tire manufacturers Goodyear and Hoosier, never regained the points lead.

Chapter 22
RATTLE HIS CAGE

Lightning may not strike twice, but Dale Earnhardt did. Each time, Terry Labonte was the recipient of the most famous—or infamous—final lap taps in Bristol history, resulting in two distinctly different outcomes.

The first, in 1995, sent Labonte's red and yellow Chevrolet sliding sideways across the start-finish line and into the outside wall. But it came too late for Earnhardt, because Labonte was able to hold on and win the Goody's 500. In the rematch, Earnhardt moved Labonte aside in turn two, thus allowing the seven-time series champion to claim his ninth and final Bristol triumph.

For most, those spectacular finishes represent the essence of Bristol racing—physical, confrontational and downright controversial.

"I won the race, so I'm not mad," Labonte said in 1995 after guiding his smoking, mangled Chevrolet into victory lane. "If he had won the race, I might be a little mad. But I don't think he intended to wreck us. We were both trying to win the race."

The contact was Earnhardt's only chance to salvage victory on a night where he came from the back of the pack twice but fell short of winning.

"I'd like to congratulate Terry," Earnhardt said afterward. "He ran a heck of a race. We couldn't catch him. I got jammed up behind them slow cars and I got into him."

NASCAR sent Earnhardt to the back of the field after he bumped Rusty Wallace into the turn four wall on lap 32. Earnhardt then charged through the pack and took the race lead before lap 200. Later, Earnhardt made

contact with a slower car, and the necessary repairs forced him to restart sixteenth, the last car on the lead lap, with less than 150 circuits remaining.

Labonte, meanwhile, had a much easier night. He moved into second place on lap four hundred and passed Dale Jarrett for the lead thirty-two laps later. After the race, Labonte admitted he'd been watching for Earnhardt in his rearview mirror as the laps clicked off.

"I saw Earnhardt get by Jarrett, and I knew he had fresher tires," Labonte said. "Ours were pretty worn." On the final lap, two lapped cars slowed Labonte's momentum and allowed Earnhardt to close.

"I was watching him in the rearview mirror when I got boxed in the traffic, trying to figure out which way he would go," Labonte said. "Then he tapped me. I stood on the gas, aimed at the finish line and here I am."

Four years and two days later, Earnhardt and Labonte reprised their duel, and this time it was even wilder.

Labonte was again leading with ten laps to go, when he narrowly escaped a backstretch crash involving Jeremy Mayfield and Wally Dallenbach. An

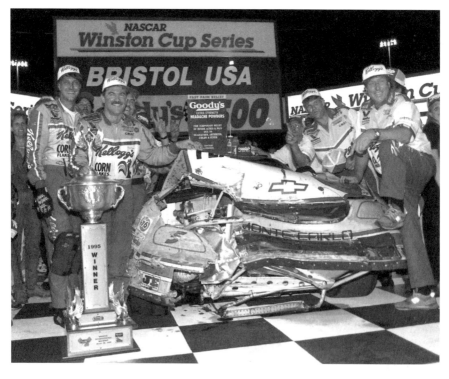

Despite the damage to his car, Terry Labonte *(second from left)* and his crew celebrate winning Bristol in 1995. Bristol Herald Courier.

instant after missing that melee, Darrell Waltrip couldn't slow down and bumped Labonte's Chevrolet.

Terry gave up the lead to pit for fresh tires and allow his crew to check for damage. He returned to the track in fifth position, trailing Earnhardt, Tony Stewart and Jeff Gordon, all of whom didn't pit, and Mark Martin, who also pitted under the late-race caution.

When the green reappeared, Labonte made short work of Stewart, Gordon and Martin and zeroed in on Earnhardt's black Chevrolet. Labonte made contact with Earnhardt while retaking lead as the white flag flew. But he probably should have waved red at a charging bull.

Earnhardt pulled up to Labonte's back bumper in the first turn and struck him as they left turn two. Labonte lost control, slid sideways out of the groove and into the backstretch wall. Earnhardt cruised to victory lane, as a cascade of boos rained down from the grandstands. More than half of the crowd seemed livid, while the rest were celebrating. At one point, track officials actually stopped broadcasting the postrace driver interviews on the public address system, because much of the massive crowd remained incensed.

Dale Earnhardt *(3)* gets Terry Labonte *(5)* sideways in turn two and wins Bristol's 1999 night race. *BMS collection.*

"Terry got into me in the middle of turns three and four," Earnhardt calmly explained after the race. "I was going to get back up to him to rattle him. I didn't mean to turn him; I just meant to rattle his cage a little."

An angry Labonte saw it differently.

"He never has any intention of wrecking anybody," Labonte said of Earnhardt. "Have you ever heard him say he meant to spin anybody out?"

Later in the press box, Earnhardt seemed intent on pleading his case that he really didn't intend to wreck the popular Texan.

"Terry caught me coming to the white flag in three and four and we bumped a little," Earnhardt said. "When we went back to one, I went back in there to get under him. Whether he checked up or I got in deeper or what, I bumped him too hard and turned him. I didn't do it intentionally. I meant to get in there and race with him."

NASCAR officials reviewed the finish for about an hour before ruling Earnhardt's win would stand. Asked by the news media whether he planned to complain to the sanctioning body, Labonte said he "wouldn't waste his time," but suggested Earnhardt "better tighten his belts up."

Chapter 23
QUITE A TRACK

Ecstatic after completing his purchase of the Bristol race track in January 1996, O. Bruton Smith couldn't wait to announce the good news. Smith completed the deal in less than two weeks, paid former owner Larry Carrier in full and was anxious to begin a series of upgrades to the east Tennessee facility.

With that in mind, he and Carrier scheduled a news conference that very evening to tell the Bristol-area news media and the Tri-Cities community. But Smith was taken aback by the apprehension and angst that filled the speedway's press box. Carrier spoke first, outlining his decision to retire and sell the speedway he'd helped create thirty-five years before. Then it was Smith's turn to thank the Carrier family and speak glowingly about the track and the future.

Once the assembled media corps began asking questions, however, it was obvious Bristol's future was a prime concern. And the first question sought assurance that the track's NASCAR race dates wouldn't be carted out of town under the cover of darkness.

"We have no intentions at all of moving any dates away from the Bristol speedway. None at all," Smith said. "We're doing everything we can to continue to have the respect of the community and to continue with the program here."

In answer to another, similar question, Smith said he was already looking at ways to increase Bristol's seating capacity and make other improvements. Still, the questions continued.

Wasn't Smith building a new track in Texas? Was he certain he wouldn't move one of Bristol's dates to get Texas on NASCAR's schedule? What about his ownership role in tradition-rich North Wilkesboro Speedway? The racing rumor mill was rampant with clues that the North Carolina track would forfeit both of its Cup dates.

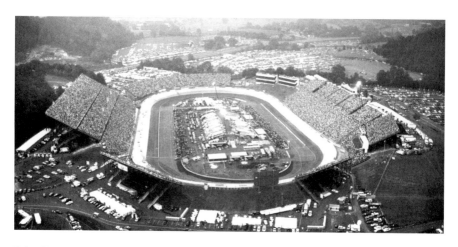

Bristol's seating capacity grew steadily to about sixty-seven thousand before Bruton Smith purchased the track in 1996. *BMS collection.*

"I give you my word," Smith said at one point, "that we will do our level best to continue what Larry has started. I think you know what we do and we want to do it in a first class manner."

Business and civic leaders from the Bristol area also attended the news conference, listening intently to Smith's assurances while fretting he might take one or both of the races elsewhere. In retrospect, the fear was misplaced given Smith's investment and unwavering support of the Bristol facility. But 1996 was a turbulent time in racing. Attendance was booming, TV ratings were climbing and NASCAR was pushing to expand beyond its traditional southeastern core to shiny new speedways in metropolitan markets.

"Who put the fear there?" Smith asked the day after the announcement. "I've not said anything that would lead anyone to believe we would move race dates from Bristol. People don't associate Bristol with North Wilkesboro."

Carrier also tried to assure folks that Smith would be good for Bristol. "I worried about that because I realize how much the economy depends on this track," Carrier said. "And I tell you, he emphatically said he was staying on here." Carrier also admitted rejecting a higher, last-minute offer from Rich Klyne, who was building a new speedway in Las Vegas, because Klyne offered no guarantee any race dates would remain with Bristol.

Spring race sponsor Food City officials were among those caught off guard. "To be honest, at the time, it scared all of us to death," grocery chain CEO Steve Smith said. "We didn't know who Bruton Smith was and what may happen to our Bristol race. But when Bruton and Jeff Byrd came aboard,

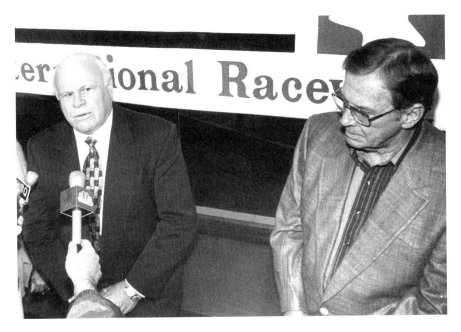

Bruton Smith *(left)* answers questions about his plans for Bristol as Larry Carrier watches during a 1996 news conference. *David McGee.*

the fun really started. Take nothing away from what Larry Carrier did, but Speedway Motorsports took the racing and the promotion to a different level."

Bruton Smith had contacted Carrier on January 10, 1996, and the final papers were signed January 22. The total price was $25.5 million, which included paying Carrier's taxes.

"One day, I called Larry up and asked what it would take to buy Bristol," Smith said. "He told me a number, and I said that's quite a figure."

"It's quite a track," was Carrier's reply.

While Smith couldn't argue with Carrier's assessment of the Bristol track, the new owner was dismayed to learn the purchase price didn't include the adjacent All-American Campgrounds. Carrier's attorney A.D. Jones said once the purchase agreement was finalized, he, Carrier and Smith toured the property.

"Over here's the campground," Carrier told Smith.

"Boy, that's a nice campground," Smith replied.

"Now you know why I wanted to keep it," Carrier said, looking straight ahead. "Keep it? You mean it's not part of it?" Smith asked.

Jones recalled Carrier just grinning. "Larry loved to get one up on somebody and that was one of his moments where he got what he wanted and more," Jones said.

Chapter 24
THE ROAD TO SUCCESS

Dust swirled around Sterling Marlin's bright yellow Chevrolet race car as it rumbled across the gravel parking lot, stopping abruptly next to a large tent containing Bristol-area civic leaders and members of the media. Just inside, Bruton Smith and Jeff Byrd were beginning to unveil the details of the total reconstruction of Smith's recently acquired Bristol Motor Speedway.

It was race week in August 1996, and Smith was about to put his indelible stamp on Bristol. The initial traces were already evident. Giant earth-moving machinery had converted a mountain into a parking lot, and parts of the property were a work zone when teams arrived. Crews labored around the clock, without days off, to complete the first twenty-four-thousand-seat expansion just in time for race fans to enjoy that weekend's Goody's 500.

"The road to success is constantly under construction," Smith told the crowd, while pointing out aspects of some conceptual artwork. "This project will make Bristol the largest sports facility in Tennessee and one of the largest in the world."

Bristol, the little track inspired by Larry Carrier and Carl Moore's 1960 visit to Smith's first track outside Charlotte, North Carolina, was about to get a world-class makeover.

Despite the cheesy stunt of having Marlin "drive up" to see what was happening, that briefing ranks as one of the significant off-track moments in the track's ample history because it offered the press and public a peak through Smith's designer sunglasses at precisely what he had in mind by adding Bristol to his group of tracks seven months before.

The computer-enhanced image provided a road map for the facility's direction for the next decade. And any lingering concerns that Bristol might lose one or both NASCAR race dates were instantly buried beneath tons of virtual earth. Here was fourteen-carat, full-color proof that not only would Bristol survive, but it was also about to reach heights only a visionary like Smith could conceive and accomplish.

It wasn't easy, and it didn't happen overnight. Growth came in stages, as seating capacity climbed from 67,000 in 1996 to 160,000 by 2005, all while maintaining an amazing streak of consecutive sold-out races until hitting the wall of a national recession.

Bruton Smith wasted no time raising Bristol's profile and its attendance to 160,000. *David McGee.*

Piece by piece, the original race track complex was dismantled and replaced. Those 1961 concrete bleachers along each straightaway gave way to tons of high-rise aluminum seating; the cramped suites inside matching buildings that once overlooked turn one were replaced by about two hundred luxury skyboxes ringing much of the upper deck; and a massive infield scoring tower complete with video screens replaced the old scoreboard.

Accommodating substantially larger crowds meant constructing more restrooms, concession and souvenir stands, concrete walkways and elevators. From parking lots and access roads, camping and fan amenities, Bristol was transformed.

After years of work and investing more than $160 million, Smith's Bristol ranks among the world's foremost cathedrals of speed. Nearly a decade after

that 1996 announcement, Smith marveled at the response to his new and improved Bristol.

"Bristol is a phenomenon. There is nothing else like it anywhere," Smith said. "We put 60,000 people in there for qualifying, 100,000 for the Busch [Nationwide Series] race and 160,000 on Sunday. That's over 300,000 people in three days. What other sports complex in the world can say that?"

More than just racing, Bristol weekends rival the world's preeminent sporting events.

"A NASCAR Cup race like at Bristol Motor Speedway will have people come ten days to two weeks early and spend their vacation around it," Smith said. "They don't even do that for the Super Bowl."

Given the success story that Bristol became, why hasn't someone else tried to replicate it? The answer is two-fold, late president and General Manager Jeff Byrd once explained:

> *To build a new race track, depending on where you built it, would cost a minimum of $300 million. You can't flow positive cash through a facility that costs that much with one Cup date and nothing else. You have to build tracks that will accommodate open-wheel cars to get that extra date. A public company couldn't afford to do it.*

Byrd once invited the Indy Car Series to bring cars to Bristol and test. In declining, a series official complimented Byrd on an "exciting" facility, noting it was "too exciting" for their series.

"You could duplicate the race track and grandstands—that's just a function of money," Byrd continued. "But it's impossible to duplicate the people of our region who open their backyards, bedrooms and fields to the race fans who come here two times a year. People love coming here because of the way they're treated. We hear it all the time."

Thousands of Tri-Cities residents who volunteer to spend race weekends parking cars, scanning tickets, serving food, checking coolers and performing similar tasks become the face of the speedway to visitors from all fifty states and a dozen foreign countries.

Smith remains unabashed in his love of the region.

"This is one of the greatest places in the world," Smith said. "I always start packing a week early to come up here."

Chapter 25

BUMP AND RUN

Jeff Gordon charged to the back bumper of Rusty Wallace's Ford, and 118,000 fans all but knew what would happen next. Racing through the final turns of the final lap of the 1997 Food City 500, Gordon executed a perfect bump and run, moving Wallace out of the way just long enough to earn the victory. Pardon me, coming through.

Far from the first to employ the textbook Bristol pass with the checkered flag waving, Gordon's execution was almost certainly the smoothest. The win broke an uncharacteristically long losing spell for Gordon, provoked many of the vocal grandstand inhabitants to express their displeasure and spoiled Wallace's plans for a victory celebration.

"I've never been a part of a last lap deal like that and it was exciting," Gordon enthused in victory lane. "It was just typical, wide-open Bristol racing. It's exciting. I've never been in a shootout like that down to the finish."

Wallace fumed after leading four times for 240 laps.

"That bugged me because he ran into the back of me and got me sideways," Wallace said. "I don't like anybody running into me to pass me."

Gordon actually hit Wallace's back bumper twice on the final lap. The first attempt, as the two cars roared down the backstretch, didn't faze the more experienced Wallace. But Gordon caught Wallace in turn three and tapped again, not hard enough to wreck him but enough to move him. The second time, Gordon jarred the steering wheel loose from Wallace's skillful hands for an instant. Gordon stuffed his Chevrolet into the hole vacated by Wallace's Ford and won by a half second.

Jeff Gordon *(24)* twice employed the Bristol bump and run to edge Rusty Wallace. *Chris Haverly.*

In its first five decades, Bristol's narrow racing groove and dizzying speeds have generated plenty of bump-and-run moves. Gordon may have even been channeling Cale Yarborough that day since Yarborough captured the 1974 Volunteer 500 in similar fashion. The difference: Cale employed a much more physical move, inflicting more damage on Buddy Baker's Ford than the scuff mark Gordon gave Wallace.

Back in the summer of 1974, Baker appeared headed for certain victory. A mountain of a man best known for keeping his right foot mercilessly planted on the accelerator pedal, Baker paced the field in Bud Moore's Ford Torino. But a late race caution waved when the engine in J.D. McDuffie's Chevrolet expired. A hasty cleanup was completed just in time for the field to resume racing with two laps remaining.

The single-file restart left Yarborough one final opportunity. Cale needed a full lap just to get close enough, pulling right up to Baker's rear bumper as they took the white flag. Exiting turn two, Yarborough powered to the inside of Baker's streaking Ford and pulled alongside as they entered turn three. The crowd, which was already standing, roared as the two leading cars slammed together. The back end of Baker's car slid up the track toward the guardrail, while Yarborough bobbled, recovered, gunned the throttle and aimed for the start-finish line.

Afterward, each man pointed an accusing finger at the other. "When a man drives into the side of your car, you aren't supposed to win," Baker claimed. "Buddy drove his car into the side of mine," Yarborough responded. "When a man has the inside groove, you just can't push him out. We were side by side going into the fourth turn and there was only room for one of us."

Giddy Bristol promoter Larry Carrier quickly pronounced the finish "the most exciting I've ever seen here" and doubtless wished Bristol's next race came sooner than the following year.

In 2002, Gordon employed the bump-and-run maneuver on Rusty Wallace sooner and won because he was fast enough to outrun retribution. Instead of the final lap, Gordon spoiled Wallace's bid for a tenth Bristol win with a couple laps remaining.

Gordon had the faster car that night, qualifying on the pole and leading 232 circuits before Wallace slipped past on lap 482. As is often the case at Bristol, slower traffic clogged Wallace's late-race path, and Gordon caught up on lap 497. Just as before, Gordon drove up to Wallace's back bumper, knocked impolitely and opened just enough space to squeeze by. Wallace called Gordon a few choice names over his team's radio, but fury didn't make his car any faster, and Gordon claimed his first night-race victory.

"To tell the truth, I was trying desperately to knock the crap out of him. I just couldn't catch him," Wallace said.

That victory broke another extended drought for Gordon.

"I wanted this one really bad," a jubilant Gordon said. What about moving Wallace out of your way? "I knew that if I could get to him, I could make a move. Rusty got real loose and shut the door on me. I knew it was fair game. I got into Rusty a little bit and he got loose—and I hope he will understand Sunday."

Gordon's win was the second time that season a physical move was rewarded with a trip to Bristol's victory lane. That spring, Kurt Busch got aggressive with Jimmy Spencer, normally not a good idea, by bumping Spencer's race-leading Dodge aside.

Spencer had just taken the lead for the third time that day by cleanly passing Busch's Ford on lap 444. But Busch drove into the back of Spencer's car off turn two, forcing him up the race track and giving Busch enough daylight to pass. With more than 50 laps remaining, few in the grandstands expected Busch to be around at the end. Spencer, who is better known as "Mr. Excitement," had a short-fuse reputation and desperately wanted to redeem himself to new team owner Chip Ganassi after missing that year's

Daytona 500. But Busch's Ford proved faster, streaking to his first Cup series win while never giving Spencer an opportunity for revenge.

"Kurt Busch just smashed right into me and that's OK," an irate Spencer said afterward. "I never forget. The only thing is, when I smash back, he won't finish."

In 2008, Carl Edwards and Kyle Busch staged one of the most memorable confrontations in recent Bristol history—after the race. Edwards led early, but Busch seemed to crush anyone else's hope of winning. After passing Edwards for the lead on lap 55, Kyle checked out, leading the next 415 consecutive laps. Edwards couldn't catch him, but a late caution bunched the field and offered Edwards one last opportunity.

When the green flag reappeared on lap 467, Edwards zeroed in on the rear bumper of Busch's colorful Toyota. Two laps later, Edwards was still there. He bumped Busch as they entered the first turn, forcing the leader up the track and opening a gap for Edwards to storm through. Edwards led the race's remaining laps and claimed his second straight night race, but things heated up on the cool-down lap.

A furious Busch drove into Edwards' slowing Ford as they rolled through the second turn, prompting the sellout crowd to boo wildly. Moments later, their displeasure turned to cheers after Edwards slammed into Busch's car, knocking him sideways. Edwards joked in victory lane the "steering wheel must have slipped out of my hands," but Busch wasn't laughing. "He does that and he'll always come back and say he's sorry," Busch said. "He did it at Milwaukee and he's done it a few other times. It's just his normal fashion."

Pressed by the media after the race, Edwards explained his thought process:

> *I had to ask myself when I went down there in the corner: should I lift and brake early and do the best I can or should I just kind of give him a little tap and see what happens? I feel like I was extremely justified to do what I did. I needed to do it and that's the way it went. Let's make it clear, I'm not apologizing for it and that's it.*

Chapter 26

DOMINATION

Whether drivers refer to racing at Bristol as flying jet fighters in a gym, driving Matchbox cars around a blender or spinning marbles in a cereal bowl, the world's fastest half mile has invoked dread in generations of race drivers. Regarded as the most physically, emotionally and mentally taxing track in NASCAR, the mere mention of Bristol can make the fearless sweat.

It always has been a tough, cantankerous bully. In the 1960s and 1970s, many winners and those who chased them couldn't go the distance, needing relief drivers to see the checkered flag. Modern cars are smaller, handle better and the technology of seat safety and driver comfort has improved. But competing at Bristol still requires razor-edge focus, dexterity and some muscle to finish five hundred dizzying laps when turns one and two begin resembling turns three and four and even champions sometimes enter the wrong side of pit road.

Despite that well-earned reputation, a select few discovered how to thrive, not just survive, at Bristol. Of its first one hundred races, a mere eleven drivers combined to win sixty-seven.

Not surprisingly, many are regarded among the best ever. Drivers with at least three Bristol wins apiece have combined for, at this writing, thirty NASCAR Cup championships and five are already enshrined in the NASCAR Hall of Fame in Charlotte, North Carolina.

Bristol victories have counted toward twenty-four season championships, beginning with Ned Jarrett's second title in 1965. Cale Yarborough scored Bristol wins in all three of his championship seasons. In addition, three of Dale Earnhardt's seven and three of Jeff Gordon's four championship years

each included a Bristol win. Richard Petty and David Pearson each count Bristol triumphs in two of their respective championship seasons.

Nearly as remarkable, fifteen times between 1970 and 2010 the winner at Bristol has gone on to finish second in the series standings. Yarborough and Waltrip, for example, each missed out on three more championships despite Bristol victories, and Bobby Allison was the points runner-up in both 1970 and 1972 after earning winner's points at Bristol.

Not every benchmark necessarily has championship implications.

In the early 1960s, Fred Lorenzen won three straight Bristol races on the track's original configuration and had a share of the fourth by providing relief help for 1965 winner Junior Johnson. After Lorenzen stepped away from the Holman-Moody team, David Pearson slid into the seat and swept three of four Bristol races in 1968 and 1969.

Starting in 1971, car owner Junior Johnson and then partner Richard Howard forged a Bristol legacy that may never be matched. The team's Chevrolets won four straight races with three different drivers—four if you count 1971 relief driver Friday Hassler—in the most dominant way imaginable.

Johnson brought Chevrolet back to NASCAR prominence in 1971, as Charlie Glotzbach won the fastest race ever run at Bristol. Together Glotzbach and Hassler led 411 of 500 laps. The following year, Bobby Allison took over the seat of Johnson's Monte Carlo and swept both 1972 Bristol races. After qualifying on the pole each time, Allison led a combined 903 of 1,000 laps.

Bobby Allison swept both Bristol races in 1972 in dominant fashion. *John Beach*.

Even that paled to Cale Yarborough's performance in the 1973 Southeastern 500. After qualifying Johnson's Chevy on the pole, Yarborough led all five hundred laps of a race completed over two weekends due to rain.

Johnson's cars led 1,814 of a possible 2,000 laps, winning by a combined 12 laps. Nobody else finished on the lead lap in any of the four races, and the closest was Richard Petty, who was two laps down to Yarborough in 1973. Petty inflicted the only blemish on near perfection by beating Glotzbach for the 1971 Volunteer 500 pole by one-tenth of one mile per hour.

Later in that same decade, Yarborough and Junior Johnson went unbeaten in four consecutive races. Cale scored eight of his nine Bristol victories in a six-year, twelve-race stint between 1973 and 1978 that included winning the first night race.

Only once, in 1975, did seven-time NASCAR champion Richard Petty sweep a Bristol season. It was a feat that amazed even Petty, who'd never enjoyed great success at the Tennessee half mile.

Darrell Waltrip took over the Junior Johnson ride in 1981 and reeled off seven straight Bristol victories between 1981 and 1984. Not coincidentally, Waltrip won two championships during that streak. Waltrip's twelve Bristol victories between 1978 and 1992 lead all drivers, and he remains the only one with double figure wins.

The ink was barely dry on Waltrip's domination when Dale Earnhardt went on a tear, winning five times in eight races, including sweeps of both the 1985 and 1987 seasons.

During the 1990s, Jeff Gordon and crew chief Ray Evernham won Bristol's spring race four straight years, tying a mark set by Waltrip.

Rusty Wallace's nine Bristol wins were scattered across three decades, but he won three of four races during the 1999 and 2000 seasons, including the fiftieth of his legendary career.

More recently, Kurt Busch won the spring race three straight times between 2002 and 2004 and added a night race win in 2003 in Jack Roush-owned Fords. Busch, who later replaced Wallace at Penske Racing, rekindled some of that magic with a 2006 win.

Kyle Busch is the latest to figure out the fastest way around Bristol, winning three of four Cup races in 2009 and 2010 for car owner Joe Gibbs. He also narrowly missed out on winning the 2008 night race, leading 415 laps before losing thanks to an aggressive bump-and-run move by Carl Edwards.

Busch's greatest display of Bristol dominance occurred in August 2010 when he won all three of NASCAR's top divisions—Sprint Cup, Nationwide and Camping World Truck—in a single weekend.

Chapter 27
STUNTS TO STUDENTS

Since its inception, Bristol Motor Speedway was supposed to host more than just racing, but the variety is truly mind boggling.

A 1961 Brenda Lee concert during its opening weekend attracted a large crowd, but subsequent concerts weren't always so successful. An all-star country show a couple years later featuring Patsy Cline, Faron Young and Skeeter Davis was a disappointment.

"We had everybody on the Grand Ole Opry, and I sat there for three days waiting for the people to show up," cofounder Carl Moore said. "Nobody came."

In the decades since, everything from bluegrass and country to classical music has echoed off the mountains in and around the race track. Country crooners Lorrie Morgan and Ricky van Shelton performed in conjunction with a city festival in the late 1990s. Loretta Lynn, Earl Scruggs and Blue Highway played outside the speedway during 2002 concerts marking the seventy-fifth anniversary of the landmark 1927 Bristol Sessions country recordings. Even the adjoining Bristol Dragway got into the act in 1984, hosting country group Alabama.

Bristol was also renowned for bringing in celebrities like boxer Rocky Marciano and football star Johnny Unitas plus every conceivable type of thrill show. Fans saw the Sensational Leighs and their "Loop Swing of Death" double Ferris wheel; Jimmy "the Flying Greek" Kourfas, who jumped a school bus over a row of motorcycles; the Hurricane Hell Drivers car stunt show; the Tournament of Thrills; and a one-hundred-car Destruction Derby.

The U.S. Army Golden Knights parachute team and the U.S. Air Force Thunderbirds also performed at Bristol. Long before Bristol had a drag strip, straight-line champion Art Malone wowed the 1961 Southeastern 500 crowd by wheeling his cackling Top Fuel dragster to a tire-smoking run down the oval track's front straightaway.

There were Soap Box Derby and USAC midget cars in the 1960s, massive monster truck exhibitions and even a gathering of Ford Model Ts. In 2000 and 2001, the world's fastest half mile was even covered with dirt to showcase the World of Outlaws sprint cars and late model stocks.

The speedway's most successful nonracing event is the annual Speedway in Lights. Patrons can view millions of Christmas lights, drive on segments of the speedway and dragway and enjoy a number of activities in the oval track pit area. Established in 1997, Speedway in Lights has generated more than $6 million for nonprofit agencies through the Bristol chapter of Speedway Children's Charities.

Among Bristol's most unique uses have been as a medical clinic, a temporary high school and hosting Dukes Fest, an event celebrating the *Dukes of Hazzard* television show.

BMS was the site of a three-day remote area medical clinic in 2010, where thousands of people received free medical and dental care.

Speedway in Lights visitors have contributed millions of dollars to Bristol-area children's organizations. *David McGee.*

Dukes of Hazzard TV show cast members *(from left)* James Best, John Schneider and Ben Jones at Dukes Fest. *Earl Neikirk*/Bristol Herald Courier.

In fall 2002, students of nearby Sullivan East High School attended classes at BMS while black mold was removed from the school's main building. That year's graduation ceremonies were also held at the track, with their principal waving the checkered flag.

At the opposite end of the serious spectrum, thousands of diehard fans of the 1980s *Dukes of Hazzard* TV show attended Dukes Fest events in 2004 and 2005.

There were dozens of orange "General Lee" Dodge Chargers, live music and members of the show's original cast, including John Schneider, Tom Wopat, Ben Jones, Catherine Bach, James Best and Sonny Shroyer, who signed autographs for hours.

A TV stunt crew even reenacted some of the show's famous moments, including a General Lee Charger flying through the air and a police car crashing to the ground. Yee haw!

Appendix
RACE RESULTS

1961

July 30: Heat forced Jack Smith to call on relief driver Johnny Allen, but together they captured the inaugural Volunteer 500 on Bristol International Speedway's grand opening weekend. Fireball Roberts finished second and Ned Jarrett third.
October 22: Mechanical problems aborted Junior Johnson's five-lap lead and allowed Joe Weatherly to drive Bud Moore's Pontiac to victory in the Southeastern 500. Rex White finished second.

1962

April 29: Bobby Johns led 430 laps to win the second Volunteer 500 by 6 laps over second-place Fireball Roberts, as Pontiac claimed its third straight Bristol race. Only eleven of thirty-six starters were running at the finish.
July 29: Jim Paschal drove a Petty Enterprises Plymouth to victory in the Southeastern 500. He beat Fred Lorenzen, who lost a wheel on the final lap, and teammate Richard Petty.

1963

March 31: Fireball Roberts ran out of gas at the finish line but was able to hold off new Holman-Moody Ford teammate and pole sitter Fred Lorenzen to win the Southeastern 500. Junior Johnson finished third in Ray Fox's Chevrolet.

APPENDIX

Fireball Roberts flies into the turn-one guardrail, as Junior Johnson runs the low line. *John Beach.*

July 28: Fastest qualifier Fred Lorenzen passed Richard Petty on the 320th lap and went on to win the Volunteer 500. Fireball Roberts flipped his Ford four times in a spectacular crash and was treated and released from a local hospital.

1964

March 22: A damaged engine nearly ruined Fred Lorenzen's dominant performance in the Southeastern 500, but he became Bristol's first repeat winner. After leading 494 laps, Lorenzen nursed his car home a half lap ahead of Fireball Roberts.

Marvin Panch *(21)* leads Fred Lorenzen, winner of three straight Bristol races in 1963 and 1964. *John Beach.*

APPENDIX

July 26: Fred Lorenzen capitalized on Richard Petty's bad luck to lead only the final lap and win the Volunteer 500. Petty's Hemi engine expired after leading 442 laps. Lorenzen got midrace relief from Ned Jarrett.

1965

May 2: Junior Johnson banged fenders with Dick Hutcherson and then narrowly edged him to claim the Southeastern 500. Hutcherson unsuccessfully protested the finish, claiming he should have been scored ahead of Johnson.

July 25: Ned Jarrett reclaimed the NASCAR points lead by outlasting persistent rain showers to win the Volunteer 500. The race marked the end of the Chrysler boycott, as Richard Petty and David Pearson returned to the series.

1966

March 20: After two straight Bristol runner-up finishes, Dick Hutcherson powered his Holman-Moody Ford to victory in the Southeastern 500. Hutcherson passed David Pearson on lap 382 and led the last 118 laps. Local independent Paul Lewis finished second.

July 24: Paul Goldsmith turned a late-race pass of Jim Paschal into victory in the Volunteer 500. Goldsmith got around the Petty-owned Plymouth with five laps remaining for his ninth NASCAR win.

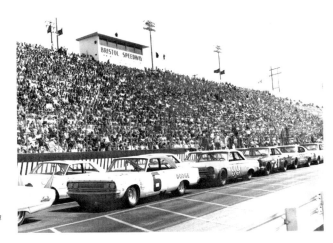

David Pearson *(6)* started his Cotton Owens Dodge on the pole for the 1966 Southeastern 500. *John Beach.*

APPENDIX

1967

March 19: David Pearson ran down Cale Yarborough with six laps remaining to win the Southeastern 500. Yarborough inherited the lead when Dick Hutcherson's engine blew on lap 482. Yarborough then cut a tire after running over debris but finished on the tire's inner liner.

July 23: Richard Petty's remarkable twenty-seven-win season included a victory from the pole in the Volunteer 500, but it wasn't easy. Petty made up three laps and took the lead for good on lap 439, while Dick Hutcherson finished second.

1968

March 17: Top qualifiers David Pearson and Richard Petty exchanged the lead six times before Pearson drove the Holman-Moody Ford to victory in the Southeastern 500. Petty won the pole for a second straight time but finished second.

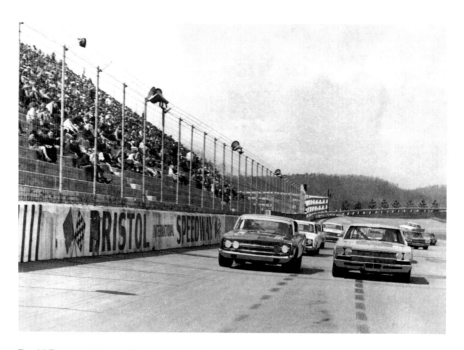

David Pearson *(left)* and Richard Petty lead the field for the 1968 Southeastern 500, won by Pearson. *John Beach.*

July 21: David Pearson earned his second straight Bristol win in the Volunteer 500 and moved to within sixteen points of the championship lead en route to his second series title. Pearson bested Cale Yarborough's Wood Brothers Mercury by one lap.

1969

March 23: Bobby Allison took advantage of late race engine problems for both Bobby Isaac and David Pearson to wheel Mario Rossi's Dodge to victory in the Southeastern 500. Allison led the final eight circuits, finishing four laps ahead of LeeRoy Yarbrough.

July 20: David Pearson overcame the flu to win the first race on Bristol's higher banking, thanks to an assist from Richard Petty. Qualifying speeds picked up about fifteen miles per hour, but attrition claimed all but ten of the thirty-two Volunteer 500 starters. Petty replaced Pearson for the final 142 laps.

1970

April 5: Donnie Allison notched his third career Grand National win in the Southeastern 500, inheriting the lead from Cale Yarborough, who blew his engine with forty-four laps remaining. Bobby Allison finished second.

July 19: Bobby Allison was the official winner of the Volunteer 500, but it was Dave Marcis who drove the final 130 laps in relief. Donnie Allison chased his brother's car across the finish line, but this time he drove LeeRoy Yarbrough's Ford in relief.

1971

March 28: David Pearson started on the Southeastern 500 pole, made up an early one-lap deficit and held off Richard Petty for his sixtieth career win. Pearson also escaped an incident with James Hylton's Ford.

July 11: Charlie Glotzbach got relief help from Friday Hassler to score Chevrolet's first-ever Bristol win in the Volunteer 500. Driving a car prepared by Junior Johnson, Glotzbach and Hassler set a race record pace of 101.074 miles per hour in a race run without a caution flag.

1972

April 9: Bobby Allison gave Junior Johnson and partner Richard Howard their second straight Bristol win by leading 458 of 500 laps in the Southeastern 500. Allison started on the pole and bested second-place driver Bobby Isaac by four laps.
July 9: In a case of déjà vu, Bobby Allison qualified on the pole and led 445 laps to win the Volunteer 500. Allison passed Richard Petty on lap 210 and led the final 290 circuits. Petty finished second, 3 laps off the pace.

1973

March 25: Cale Yarborough, who replaced Bobby Allison in the Junior Johnson Chevrolet, led all five hundred laps to claim the rain-delayed Southeastern 500. The race was originally scheduled for March 11.
July 8: Benny Parsons got relief help from John A. Utsman to win the Volunteer 500, the lone win in Parsons's 1973 Winston Cup championship season. Despite two driver changes, the duo beat second-place L.D. Ottinger by seven laps.

1974

March 17: Cale Yarborough outran snow flurries and a flock of Chevrolets to capture the Southeastern 500. Yarborough finished a lap ahead of second-place Bobby Isaac and two laps in front of Benny Parsons.
July 14: Cale Yarborough and Buddy Baker staged a furious, fender-banging last-lap battle before Yarborough's Chevrolet edged Baker's Ford by three car lengths in the Volunteer 500. Only a third of the field was running at the finish.

1975

March 16: Richard Petty dominated the Southeastern 500, beating second-place Benny Parsons by six laps. Petty led three times for 242 laps, including the final 130.
November 2: Richard Petty collected the thirteenth and final win of his sixth championship season by edging Lennie Pond in the Volunteer 500. Darrell Waltrip scored his first Bristol top-five finish, running third in a Chevrolet.

1976

March 14: Cale Yarborough took the lead from Darrell Waltrip on lap 183 and never looked back to win the Southeastern 400. Yarborough's Junior Johnson Chevrolet led 285 laps of an event shortened due to the national energy crisis.

August 29: Cale Yarborough raced past Darrell Waltrip on the twenty-eighth lap and dominated the remainder of the Volunteer 400. A crowd of just twelve thousand saw the South Carolina driver finish two laps in front of second-place Richard Petty.

1977

April 17: Cale Yarborough turned in the second most dominant performance in Bristol history, qualifying on the pole and leading 495 laps to win the Southeastern 500. Dick Brooks finished 7 laps down in second place.

August 28: A late race caution for rain in the Volunteer 400 assured Cale Yarborough of his fourth straight Bristol win. Darrell Waltrip, driving the only other car on the lead lap, settled for second.

1978

April 2: Darrell Waltrip overcame fender damage from an early crash and etched his name into the Bristol record books by winning the Southeastern 500. Waltrip's DiGard Chevrolet finished a lap ahead of Benny Parsons.

August 26: Bristol's first night race featured two bumping incidents between pole sitter Lennie Pond and Darrell Waltrip, who later watched Cale Yarborough wheel Junior Johnson's Oldsmobile to the Volunteer 500 victory.

1979

April 1: Dale Earnhardt became the first rookie to ever win at Bristol, as he captured his initial NASCAR victory in the Southeastern 500. Driving an unsponsored Chevrolet for car owner Rod Osterlund, Earnhardt turned back Bobby Allison and Darrell Waltrip.

Dale Earnhardt waves to the crowd after earning his first Winston Cup win in the 1979 Southeastern 500. *BMS collection.*

August 25: Darrell Waltrip capitalized on a spin by leader Benny Parsons with just fourteen laps remaining and held off Richard Petty to win the Volunteer 500. Petty won the pole in a Chevy Caprice but led only seventy-seven laps.

1980

March 30: Dale Earnhardt staked his claim as an early favorite to win that season's championship by winning the Valleydale 500 for the second straight year. Darrell Waltrip and Bobby Allison finished second and third, respectively.

August 23: Cale Yarborough withstood a furious last-lap charge from Dale Earnhardt to win the Busch Volunteer 500. Earnhardt pulled alongside Yarborough's Chevrolet but had to back off when a lapped car blocked his path.

APPENDIX

Cale Yarborough captured his ninth Bristol victory at the 1980 night race. *John Beach.*

1981

March 29: Darrell Waltrip scored his third win of the young season, and the first of seven straight at Bristol aboard Junior Johnson's Buick, in the Valleydale 500. Ricky Rudd finished second, and Bobby Allison third.

August 22: Darrell Waltrip led 251 laps, including the final 82, to dominate the Busch 500 and claim his eighth victory of the season. Just as in March, Ricky Rudd ran second in Waltrip's former ride, the DiGard Chevy.

1982

March 14: Darrell Waltrip scored his fortieth NASCAR victory by leading the last 103 laps of the Valleydale 500, besting second-place Dale Earnhardt

by thirteen seconds. Earnhardt led 255 laps before his Bud Moore Ford was involved in a crash on lap 398.

August 28: Darrell Waltrip continued his Bristol mastery, scoring a disputed victory in the Busch 500. Waltrip took the lead on the race's final period after race officials had to sort out the running order.

1983

May 21: Darrell Waltrip's Junior Johnson team switched sponsors and car makes but not their winning ways. Waltrip took the Valleydale 500 for the third straight year, besting Bobby Allison in the lone spring race run at night.

August 27: A ferocious thunderstorm reduced the Busch 500 to 419 laps, as Darrell Waltrip edged Dale Earnhardt by beating him out the pits on the final pit stop. Bobby Allison was the only other car on the lead lap and finished third.

1984

April 1: While he didn't dominate, Darrell Waltrip made his seventh straight visit to Bristol's victory lane in the Valleydale 500. Waltrip came from a lap down to take the lead from Tim Richmond and pace the final forty-four circuits.

August 25: Terry Labonte escaped crashes with Dale Earnhardt and Neil Bonnett to capture the Busch 500 and stop Darrell Waltrip's stranglehold. Waltrip's bid for a record-breaking eighth straight win was foiled by broken rear-end gear.

1985

April 6: Dale Earnhardt added to his legend, winning the Valleydale 500 despite power steering failure after one hundred laps. Earnhardt wrestled his Richard Childress Monte Carlo to a 1.1-second win over Ricky Rudd in a race postponed one week by rain.

August 24: Dale Earnhardt booted Tim Richmond out of the way with eighteen laps remaining and held on to win the Busch 500 by three car lengths. Richmond finished second in the first prime time telecast of a NASCAR race.

APPENDIX

1986

April 6: Rusty Wallace led 174 laps and earned his first Winston Cup series victory in the Valleydale 500. Wallace's Pontiac pulled away from second-place Ricky Rudd, winning by 10.6 seconds.

August 23: Darrell Waltrip and Junior Johnson returned to Bristol's victory lane with a convincing Busch 500 win. After starting tenth, Waltrip paced the final 144 circuits and beat second-place Terry Labonte by 8.5 seconds.

Rusty Wallace sprays champagne after winning his first NASCAR race, Bristol's 1986 Southeastern 500. *Earl Neikirk*/Bristol Herald Courier.

1987

April 12: Dale Earnhardt led 134 laps, including the final 115, to win the Valleydale Meats 500, after bumping Sterling Marlin's Olds out of the lead. Richard Petty trailed the Richard Childress Chevrolet by 0.78 seconds.
August 22: Dale Earnhardt led six times for 415 laps to dominate the Busch 500. Earnhardt passed Richard Petty and paced the final 152 laps. Rusty Wallace led just 1 lap and finished a solid second.

1988

April 10: Bill Elliott collected his lone career short-track victory in the Valleydale Meats 500, despite being rooted out of the lead by second-place Geoff Bodine on lap 491. Elliott recovered and won by two car lengths over Mark Martin, with Bodine third.
August 27: Dale Earnhardt denied Bill Elliott his second straight Bristol win, besting the Georgia ace by a car length in the Busch 500. Despite finishing second, Elliott took the Winston Cup points lead from Rusty Wallace.

1989

April 9: Rusty Wallace survived a record twenty-caution flag slugfest to grab the Valleydale Meats 500, a race also marked by thirty-three lead changes among sixteen drivers. Wallace led the final sixty-three laps and won by 0.26 seconds over Darrell Waltrip.
August 26: Darrell Waltrip inherited the lead from a spinning Dale Earnhardt and paced the final 206 circuits to claim the Busch 500. Pole sitter Alan Kulwicki finished second, five seconds behind the leader.

1990

April 8: Davey Allison assumed the lead with 109 laps remaining, after opting not to pit for fresh tires, and held off Mark Martin by eight inches to win the Valleydale Meats 500. Allison became the first driver pitted on the backstretch to win at Bristol.

August 25: Ernie Irvan won a spirited battle with Rusty Wallace to score his first Winston Cup victory and the first for Morgan-McClure Motorsports in the Busch 500. Irvan took the lead on lap 411 when Dale Earnhardt pitted to replace a cut tire.

1991

April 14: Rusty Wallace won a landmark Valleydale Meats 500 that included forty lead changes, a rain delay and a scoring controversy. Wallace twice came from two laps down to be contender. Ernie Irvan was second.
August 24: Alan Kulwicki triumphed over a deteriorating track surface that created cut tires and accidents aplenty to win the Bud 500. Kulwicki came from two laps down to pass Mark Martin for the lead with 137 laps remaining.

1992

April 5: Alan Kulwicki started on the pole and led 282 laps to win the Food City 500, stopping Bill Elliott's four-race 1992 win streak. Kulwicki twice decided to take track position over fresh tires on yellow flag pit stops.
August 29: Darrell Waltrip earned his twelfth and final Bristol victory in the Bud 500, as the track debuted its controversial concrete surface. Waltrip was the first to adapt to the conditions, leading the last 133 laps and beating Dale Earnhardt by 9.28 seconds.

1993

April 4: Rusty Wallace performed a "Polish victory lap" to honor his fallen friend, Alan Kulwicki, after dominating the Food City 500. Kulwicki and three others died in a plane crash en route to Bristol.
August 28: Pole sitter Mark Martin lost two laps on a green-flag pit stop but roared back to capture the Bud 500. Rusty Wallace led much of the contest but watched Martin slip by to lead the final thirteen laps.

1994

April 10: Dale Earnhardt's patience paid off, as a caution flag near the end of a round of green flag pit stops trapped most of the field a lap down and opened the door for the "Intimidator" to win the Food City 500 over Ken Schrader.

August 27: Rusty Wallace took the lead on lap 456, after Geoff Bodine experienced engine problems, and then held off Mark Martin to win the Goody's 500. Dale Earnhardt finished third.

1995

April 2: Jeff Gordon qualified on the front row and led 205 laps, including the final 99, to earn his first Food City 500 trophy. Pole winner Mark Martin had to pit for tires late in the day, allowing Rusty Wallace to finish second.

August 26: Terry Labonte slid across the start-finish line sideways, and the front end of his Chevrolet Monte Carlo slammed into the concrete wall, but he held on to win the Goody's 500. Dale Earnhardt, who tapped the rear of Labonte's car, finished second by 0.1 second.

1996

March 31: Jeff Gordon overcame persistent rain and snow showers to win the weather-abbreviated Food City 500. NASCAR called the race complete after 342 laps, as Gordon collected his second straight spring race trophy.

August 24: Rusty Wallace inflicted some pain on the rest of the field, pacing the final 161 laps en route to his sixth Bristol win in the Goody's Headache Powders 500. Jeff Gordon and pole winner Mark Martin finished second and third, respectively.

1997

April 13: With more than 118,000 fans watching, Jeff Gordon employed a last lap bump-and-run maneuver on race leader Rusty Wallace to claim his third straight Food City 500 victory. An upset Wallace finished second.

August 23: Dale Jarrett narrowly edged Mark Martin by 0.1 seconds to collect his first short-track win in the Goody's Headache Powders 500. Jarrett's Ford led four times for 210 laps, passing Martin the final time on lap 470.

1998

March 29: Jeff Gordon's "Rainbow Warriors" gave him the lead during the final pit stop of the Food City 500, enabling Gordon to tie Darrell Waltrip's record of four straight Bristol spring race victories. Terry Labonte finished a half second behind.

August 22: An emotionally drained Mark Martin dedicated his Goody's Headache Powder 500 victory to his late father, Julian, who died in a plane crash three weeks before. Martin took the lead for good on lap 320 and won by 2.1 seconds over teammate Jeff Burton.

1999

April 11: Rusty Wallace started on the pole, led four times for 425 laps and edged Mark Martin by a car length to win the Food City 500. It was the forty-ninth win of Wallace's storied career and his seventh at Bristol.

August 28: Dale Earnhardt bumped leader Terry Labonte's Chevrolet aside as they exited turn two on the final lap of the Goody's Headache Powder 500. The tap sent Labonte sliding, Earnhardt to victory lane and the sellout crowd into a frenzy.

2000

March 26: Rusty Wallace needed a year to rack up his fiftieth victory, but that made it all the sweeter, as he captured the Food City 500. Wallace took the lead for good on lap 425 and outran Johnny Benson to the checkered flag.

August 26: Rusty Wallace proved as hot as the flamed paint scheme of his Ford Taurus, qualifying on the pole and leading five times en route to winning the Goracing.com 500.

APPENDIX

2001

March 25: Elliott Sadler captured his first Winston Cup Series win and the first at Bristol for the Wood Brothers in the Food City 500. Pitting on the backstretch, the team opted for track position over fresh tires. John Andretti, driving for Petty Enterprises, was second.

August 25: Tony Stewart withstood a late-race charge by Kevin Harvick to collect the checkered flag in the Sharpie 500. Stewart secured the top spot for good on lap 432. Harvick finished second in his first season for Richard Childress.

2002

March 24: Kurt Busch rooted Jimmy Spencer's Dodge out of the lead on lap 445 and went on to collect his first career win in the Food City 500. The pair exchanged the lead three times in three laps but an upset Spencer settled for second.

August 24: Jeff Gordon bumped leader Rusty Wallace's Ford on lap 498 and held on to collect his first night-race victory in the Sharpie 500. After leading much of the event, Gordon had to come through the pack to end a long winless streak.

2003

March 23: A week after losing an epic last-lap battle with Ricky Craven at Darlington, South Carolina, Kurt Busch paced the final ninety-seven circuits to win the Food City 500. Busch held off the Ford of teammate Matt Kenseth. Ryan Newman shattered the track qualifying record with a 14.9-second lap.

August 23: Kurt Busch passed Kevin Harvick and led the final 121 laps to win the Sharpie 500, a race slowed by a record-tying twenty cautions. Harvick finished second, and rookie Jamie McMurray was third.

2004

March 28: Kurt Busch didn't follow crew chief Jimmy Fennig's directive to pit for tires, a decision that gave him the lead and ultimately victory in the Food City 500.

August 28: Dale Earnhardt Jr. carved out a slice of Bristol history, becoming the first driver to sweep both the Sharpie 500 Cup Series race and the prior night's Food City 250. Despite starting thirtieth, Earnhardt's Chevrolet led six times for 295 laps.

2005

April 3: Kevin Harvick overcame a pit road problem with 125 laps remaining to win the Food City 500. Harvick charged through the field and passed leader Greg Biffle on lap 434. Elliott Sadler finished second.

August 27: Matt Kenseth turned in a Bristol performance for the ages, qualifying on the pole, leading nine times for 415 laps and driving his Jack Roush Ford to victory in the Sharpie 500.

2006

March 26: Kurt Busch performed a mock snow angel on the start-finish line after wheeling his Penske Dodge to victory in the Food City 500. On a weekend when snow and rain created havoc with the schedule, Busch passed Matt Kenseth and led the final five laps.

August 26: Matt Kenseth slipped past Dale Earnhardt Jr. on lap 399 and led all but 1 of the final 102 laps to claim his second consecutive Sharpie 500 victory. Kyle Busch mounted a late race charge to take second, while Earnhardt Jr. was third.

2007

March 25: Kyle Busch sharply criticized NASCAR's "Car of Tomorrow," but that didn't stop him from winning the Food City 500. Busch passed Denny Hamlin on lap 485 and withstood Bristol's first green-white-checker overtime finish to win in the car's debut.

August 25: Carl Edwards and fastest qualifier Kasey Kahne exchanged the lead five times in the first 350 laps, but it was all Edwards in the final 130 circuits of the Sharpie 500. Kahne led 305 laps in his Dodge but trailed at the finish by 1.4 seconds.

2008

March 16: Jeff Burton muscled past Denny Hamlin on the final green-white-checker restart, led just two laps and held on to win the Food City 500. Richard Childress teammates Kevin Harvick and Clint Bowyer finished second and third.

August 23: Carl Edwards and Kyle Busch engaged in a little fender banging both during and following the Sharpie 500 to the delight of the sellout crowd. Edwards employed the bump and run to edge past Busch and lead the race's final thirty-one circuits.

2009

March 22: Kyle Busch qualified midpack but charged forward to lead 378 laps on his way to winning the Food City 500, the first Cup series BMS win by a Toyota. Teammate Denny Hamlin ran second in another overtime finish.

August 22: Kyle Busch withstood a furious late race charge from pole sitter Mark Martin to win the Sharpie 500. A late red flag and restart with four laps remaining allowed Martin to pull alongside Busch, but he couldn't complete the pass.

2010

March 21: Reigning NASCAR champion Jimmie Johnson scratched a Bristol win off his bucket list, powering his Hendrick Motorsports Chevrolet past Tony Stewart to win the Food City 500. A late race restart set up the shootout, and Johnson won by 0.8 seconds.

August 21: Kyle Busch made NASCAR history by sweeping all three top-tier races during the August weekend. Busch led 282 laps, beating second-place David Reutimann to win the Irwin Tools Night Race.

BIBLIOGRAPHY

Brown, Allen E. *The History of America's Speedways Past & Present*. Comstock Park, MI: Allen E. Brown, 2003.

Fielden, Greg. *Charlotte Motor Speedway*. Osceola, WI: MBI Publishing Co., 2000.

———. *Forty Years of Stock Car Racing*. Vols. 1–4. Surfside Beach, S.C.: Galfield Press, 1990.

———. *Forty Years of Stock Car Racing Plus Four*. Surfside Beach, S.C.: Galfield Press, 1994.

Golenbock, Peter, and Greg Fielden. *NASCAR Encyclopedia: The Complete Record of America's Most Popular Sport*. St. Paul, MN: Motorbooks International, 2003.

Grubba, Dale. *Alan Kulwicki NASCAR Champion Against All Odds*. Middleton, WI: Badger Books, LLC, 2009.

Higgins, Tom, and Steve Waid. *Junior Johnson Brave in Life*. Phoenix, AZ: David Bull Publishing, 1999.

McGee, David M., and Sonya Haskins. *Bristol Motor Speedway, Images of Sports*. Charleston, S.C.: Arcadia Publishing, 2006.

NASCAR. *NASCAR Sprint Cup Series Media Guide*. Daytona Beach, FL: NASCAR Media Group, 2010.

Phillips, Benny. *Bristol Motor Speedway, 40 Years of Thunder*: Charlotte, NC: UMI Publications, 2001.

Pierce, Daniel S. *Real NASCAR, White Lightning, Red Clay and Big Bill France*. Chapel Hill: University of North Carolina Press, 2010.

Bibliography

Waltrip, Darrell, with Jade Gurss: *DW, A Lifetime Going Around in Circles*. New York: G.P. Putnam's Sons, 2004.

Yarborough, Cale, and William Neely. *Cale: The Hazardous Life and Times of the World's Greatest Stock Car Driver*. New York: Times Books, 1986.

Zeller, Bob, and Rusty Wallace. *Rusty Wallace: The Decision to Win*. Phoenix, AZ: David Bull Publishing, 1999.

Newspapers and Periodicals

Bristol (Virginia) Herald Courier
Circle Track Magazine
NASCAR Scene (formerly *Grand National Scene* and *Winston Cup Scene*)
National Speed Sport News
Southern Motorsports Journal
Speedway Illustrated
Sports Illustrated
Stock Car Racing Magazine

Internet Reference Sites

Bristol Motor Speedway, www.bristolmotorspeedway.com.
Racers Reunion.com, www.racersreunion.com.
Racing-Reference.info, www.racing-reference.info.
Ultimate Racing History.com, www.ultimateracinghistory.com.

INDEX

A

Allen, Johnny 24, 26, 27, 29, 30, 31, 32, 40, 42, 121
Allison, Bobby 42, 49, 52, 54, 55, 56, 59, 67, 69, 86, 116, 125, 126, 127, 128, 129, 130
Allison, Davey 91, 93, 132
Allison, Donnie 125

B

Baker, Buck 26
Baker, Buddy 30, 53, 56, 75, 112, 113, 126
Baker, Gary 23, 61, 62, 63, 64, 66, 74
Blackburn, Gene 73
Bodine, Geoff 90, 132, 134
Bonnett, Neil 69, 79, 130
Burton, Jeff 71, 135, 138
Busch, Kurt 71, 113, 114, 117, 136, 137
Busch, Kyle 114, 117, 138

C

Carrier, Larry 13, 14, 15, 16, 17, 18, 19, 23, 24, 28, 31, 36, 39, 40, 41, 42, 44, 70, 71, 72, 73, 74, 78, 80, 81, 88, 90, 94, 95, 105, 106, 107, 108, 113
Childress, Richard 76, 87, 98, 130, 132, 136, 138

E

Earhart, Charles 20, 21, 22, 23
Earnhardt, Dale 34, 65, 66, 70, 71, 75, 76, 77, 79, 80, 84, 86, 87, 89, 91, 97, 98, 99, 100, 101, 102, 103, 104, 115, 117, 127, 128, 129, 130, 132, 133, 134, 135
Earnhardt, Dale, Jr. 87, 137
Edwards, Carl 114, 117, 137, 138
Elliott, Bill 79, 80, 89, 91, 93, 94, 99, 100, 132, 133, 136, 137

INDEX

F

France, Bill 13, 14, 15, 16, 24, 25, 41, 74
France, Bill, Jr. 62

G

Glotzbach, Charlie 34, 49, 50, 51, 52, 53, 116, 117, 125
Goldsmith, Paul 45, 123
Gordon, Cecil 53, 55
Gordon, Jeff 34, 70, 71, 86, 97, 99, 103, 111, 112, 113, 115, 117, 134, 135, 136

H

Hall, Barney 28, 65
Hammond, Jeff 69, 91
Hampton, Andy 45, 47
Hassler, Friday 34, 51, 52, 53, 116, 125
Hayter, Fred 32, 33, 34, 63, 82
Hester, Lanny 23, 61, 62, 63, 64
Hodgdon, Warner 23, 64, 66, 70, 72, 73, 74, 78
Holman-Moody 26, 42, 116, 121, 123, 124
Hutcherson, Dick 123, 124
Hylton, James 52, 53, 125

I

Irvan, Ernie 133
Isaac, Bobby 55, 125, 126

J

Jarrett, Dale 89, 94, 97, 102, 135
Jarrett, Ned 26, 27, 30, 86, 115, 121, 123
Johnson, Jimmie 138

Johnson, Junior 26, 27, 28, 49, 50, 51, 52, 54, 55, 56, 58, 60, 65, 66, 67, 68, 70, 85, 86, 94, 116, 117, 121, 123, 125, 126, 127, 129, 130, 131
Jones, A.D. 72, 73, 74, 107

K

Kenseth, Matt 136, 137
Kulwicki, Alan 70, 89, 91, 93, 94, 95, 96, 97, 132, 133

L

Labonte, Bobby 97
Labonte, Terry 34, 70, 75, 85, 97, 98, 99, 101, 102, 103, 104, 130, 131, 134, 135
Lorenzen, Fred 26, 40, 116, 121, 122, 123
Lund, Tiny 26, 28

M

Marcum, John 46
Marlin, Coo Coo 54, 55, 56
Marlin, Sterling 75, 90, 108, 132
Martin, Mark 103, 132, 133, 134, 135, 138
McDuffie, J.D. 43, 112
Moore, Carl 13, 14, 15, 16, 17, 19, 23, 24, 26, 28, 31, 36, 38, 39, 40, 44, 60, 61, 66, 108, 118

N

Nab, Herb 49, 56

O

Ottinger, L.D. 59, 126

INDEX

P

Parsons, Benny 45, 46, 47, 48, 57, 58, 59, 63, 126, 127, 128
Paschal, Jim 26, 40, 121, 123
Pearson, David 26, 43, 53, 55, 86, 116, 123, 124, 125
Pearson, Larry 100
Petty, Kyle 82, 91
Petty, Richard 26, 30, 34, 43, 45, 49, 50, 52, 55, 56, 65, 67, 69, 86, 116, 117, 121, 122, 123, 124, 125, 126, 127, 128, 132
Pope, R.G. 17, 18, 23, 24, 25, 28, 31, 36, 39
Punch, Jerry 99, 100
Purcell, Pat 14, 15, 17, 25, 26, 40

R

Richmond, Tim 79, 80, 130
Roberts, Fireball 26, 29, 30, 34, 41, 121, 122
Roush, Jack 117, 137
Rudd, Ricky 75, 129, 130, 131

S

Sadler, Elliott 136, 137
Schrader, Ken 91, 134
Scott, Wendell 34, 73
Smith, Bruton 11, 23, 71, 105, 106, 107, 108, 109, 110
Smith, Jack 24, 29, 30, 31, 32, 40, 42, 121
Smith, Steve 84, 85, 86, 87, 106
Speed, Lake 77
Stewart, Tony 103, 136, 138
Stott, Ramo 44, 46, 47, 48

T

Thompson, Gene 38, 40

U

Utsman, John A. 57, 58, 59, 126

W

Wallace, Kenny 82, 97
Wallace, Mike 77
Wallace, Rusty 70, 71, 75, 97, 98, 99, 100, 101, 111, 112, 113, 117, 131, 132, 133, 134, 135, 136
Waltrip, Darrell 35, 62, 63, 65, 66, 67, 68, 69, 70, 71, 76, 79, 80, 81, 82, 87, 88, 90, 91, 103, 117, 126, 127, 128, 129, 130, 131, 132, 133, 135
Waltrip, Michael 81, 82, 83
Watson, Bobby 45, 46, 47, 72
Weatherly, Joe 26, 28, 41, 121
White, Rex 26, 28, 40, 121
Wood Brothers 43, 55, 125, 136

Y

Yarborough, Cale 34, 43, 53, 54, 55, 56, 58, 59, 60, 63, 69, 112, 113, 115, 116, 117, 124, 125, 126, 127, 128, 129
Yunick, Smokey 30

ABOUT THE AUTHOR

David M. McGee is an award-winning journalist working for the *Bristol Herald Courier* in Bristol, Virginia. In addition to being the author of two books, *Bristol Motor Speedway: Images of Sports* and *Bristol Dragway: Images of Sports*, he is the speedway's senior public address announcer. His writing and photography have been published in more than a dozen national motorsports magazines, including *Super Chevy*, *Super Stock & Drag Illustrated*, *Mopar Muscle* and *Drag Review*. A central Kentucky native with a lifelong fascination with motorsports, McGee is a graduate of Morehead State University with a degree in journalism.